Luciano Bellosi

GIOTTO complete works

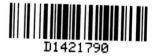

Assisi, Upper Church.

1. View towards the altar.

For most people Giotto is the first name in European painting nce antiquity. That he had breathed fresh life into painting was cognized by his contemporaries, and later by Ghiberti and Vasari. Ie had 'that art which had been buried for centuries by the errors of ome who painted more to please the eyes of the ignorant than the tellect of the wise,' wrote Boccaccio (some ten years after the artist's eath) in a tale of the *Decameron*, in which he stressed both the hysical ugliness and lively wit of 'the best painter in the world.'

Before Giotto, painting was still considered a craft, a 'mechanial' art. Giotto came to occupy a position of great respect in Florence, city that was one of the most important centres of trade and ommerce in Europe. He was representative of that spirit of ratioality and efficiency typical of the Florentine mercantile class of the me. Though he was employed by the Bardi and Peruzzi families, wners of the most important European banking houses of the day, e never limited his activity to Florence, and prestigious commissions other parts of Italy kept him constantly on the move. He worked at ne Basilica of San Francesco at Assisi, then one of the most rominent churches in Christendom; for the Pope; for Enrico crovegni, the richest and most influential citizen of Padua; for the ing of Naples; for Azzone Visconti, the Signore of Milan and he rovided the high altarpiece for St. Peter's, Rome. At a time when aly's flourishing economy made every Italian city an independent ultural and artistic centre, Giotto transcended regional barriers and ne impact of his art was felt throughout the peninsula.

He was born in about 1265, and must have been active before he last decade of the thirteenth century. The first clear signs of the ature of his artistic revolution are to be found in fresco decorations he Upper Church at Assisi: the Old Testament scenes starting with Isaac Blessing Jacob, the Vault decorated with the Doctors of the Church, the New Testament scenes including Christ among the Doctors and the Lamentation, and the St. Francis cycle. Despite the lick of knowledge surrounding Giotto's formative years, these rescoes can be considered the turning point of his early career.

Not everyone agrees that they were conceived and executed by ne artist who later painted the frescoes in the Arena Chapel in adua. Indeed, some feel that the Assisi frescoes were merely inuenced by Giotto's art, that they were painted after the Paduan escoes, or that they are a product of the Roman school. These views vere first advanced by art historians of undoubted competence and re still held by many.

It is unlikely that the Assisi frescoes were painted after those at adua. Space does not permit me to go into detail, but I shall give one sample. If we consider the small angels (or would it be better to call nem angelic spirits?) that appear in scenes such as the *Lamentation* nd the *Confession of the Woman of Benevento* in the St Francis cycle, re notice that they are cut off at the waist and terminate in drapery. his is in complete accordance with thirteenth-century iconography, nd can also be seen in paintings by Cimabue. This detail, then, rould appear to date the Assisi frescoes to a pre-Paduan period, and ther details link them more specifically to the style of Cimabue.

There is a tendency to overlook the link between Giotto and his reat Florentine predecessor, Cimabue. If we compare the Paduan and Assisi frescoes, we notice the difference between the softness and uidity of the former and the sharp incisiveness of the latter, which

gives the drapery an almost metallic appearance while the colours seem almost transparent.

Cimabue, from the destroyed *Crucifix* in Santa Croce to the *Evangelists* in the vault of the crossing of the Upper Church at Assisi, had employed similar 'transparent' colour. In this respect his *Madonna and Child* in the Collegiata of Castelfiorentino is particulary close to Giotto's frescoes in the Upper Church. Duccio, whose style was, in part, derived from the work of Cimabue, had borrowed the splendid chromatic subtleties of his *Rucellai Madonna*, now in the Uffizi, from the Florentine master. This use of colour in Giotto's Assisi frescoes separates them in time from the Paduan ones. It also suggests a parallel between Giotto's early activity and Duccio's development, from the transparency of colour in early works like the *Rucellai Madonna* of 1285, to the chromatic density of his *Maestà* in Siena, painted between 1308 and 1311.

Giotto was probably working in Assisi by about 1290, more than a decade before he began work on the Arena Chapel. The St. Francis cycle was probably painted at about this time, though it is usually dated after 1296 (Vasari records that the cycle was commissioned by Giovanni da Murro, who only became General of the Franciscans in 1296). This is not the place to examine the reason for this dating, suffice to say that Cimabue's influence, mentioned above, plus the suggested parallel with Duccio's painting, and the irreconcilable stylistic differences between the Assisi and Paduan frescoes can be only explained by the existence of a long interval between the execution of the two cycles. The difference between the St Francis and Paduan cycles is much greater than that between the St Francis cycle and Giotto's other frescoes in the Upper Church. This indicates that the interval between the St Francis and Paduan cycles must have been much longer than that between the St Francis cycle and the other Assisi frescoes.

In spite of the impression of unity created by the Upper Church frescoes, those by Giotto are easily distinguished, not only for their style, but also because they display a completely new concept. That fresco technique had changed radically by the time Giotto began work on his frescoes, is evident from their state of preservation. The disastrous condition of Cimabue's frescoes (already noted by Vasari) is due to his faulty use of pigments and to the old practice of plastering as large an area as the scaffolding would permit. Giotto painted on several relatively small patches of plaster, as large as could be comfortably painted in a day. As the plaster was always wet, the pigment penetrated deeply and uniformly, ensuring the preservation of the colours. In this way only the final touches had to be painted on dry plaster, whereas the method used by Cimabue required that large areas be painted a secco, (i.e. when the plaster was dry).

However, the technique was not the only novelty, since the very conception of the fresco had changed drastically. Cimabue and his contemporaries had regarded the wall as a surface to be covered with two-dimensional representations. The decorations around the margins of the pictures were conceived as flat ornamentation, similar to that of a tapestry or miniature, and included large plant motifs, ribbons and other ornamental elements painted in flat, bright colours. But Giotto's frescoes create the impression of being framed by the very architecture of the church, and the scenes are represented three-dimensionally, as they would appear in the real world.

The walls on which the scenes of the life of St. Francis appear, which project out slightly beyond the upper part of the wall, have been elaborated by painted mock architectural elements. This begins with the painted curtain running beneath the scenes of St Francis and culminates in the fictive architectural framing of the scenes. Each bay of the nave is divided into three sections (four in the case of the wider bay nearest the entrance) by twisted columns rising from the base painted so that it appears to project above the architrave.

So resolute was Giotto's desire to impose this system of architectural illusionism that when the fictive framings meet the projection of a real rib descending from the vault they are seen to slant downwards when viewed from the side. The fact that the same framing appears to be perfectly horizontal when viewed from the centre provides a valuable indication of what the artist considered to be the ideal position for looking at the frescoes.

The scenes of the life of St. Francis appear to be set in space behind the mock architectural framework, which has been painted to appear as part of the walls of the church. This gives the effect of looking into a series of small rooms, and calls to mind Leon Battista Alberti's concept (when discussing painting in the fifteenth century) of the surface of a painting as an open window through which we imagine we are seeing what is represented.

The scenes are planned according to principles of perspective that were first formulated in the two scenes from the life of Isaac on the upper walls. In these frescoes the delicate yet rationally articulated architectural setting creates a space that is clearly defined: the pale ochre sheet, whose edges are clearly detached from the bed underneath it; the partly drawn curtain and the horizontal rods that support it, one in the foreground, the other in the background; the foreshortened side wall with its oblique opening; the light-coloured columns in the foreground; the small windows in the dark wall at the back; Isaac's halo, which blocks out part of the head of the servant who supports him from behind. The space thus created is very shallow, but it is just this constriction that makes it seem perfectly measurable. The effect of coherence is heightened by the disposition and treatment of the figures, whose solidity is established by their gravity of attitude, the depth of the folds in the clothing, the strong modelling and the single light source.

There can be no doubt that such a coherent conception of space was regarded as a discovery, and that it was an innovation immeasurable value to the future of Western painting. It was just the methodically constructed space of the Assisi frescoes that met wit immediate and widespread acclaim, first in Italy, and then abroad especially from the second half of the fourteenth century.

Giotto was prepared to eliminate unnecessary complexity for the sake of putting his new ideas into effect with maximum clarificand consistency. His painting is much less ornate than that whice preceded it, especially when compared with the intricate, teeming compositions of Cimabue and the young Duccio, who with the cold, transparent colours sometimes achieved extraordinarily so and ethereal effects. By contrast, Giotto's painting is much simpleand more succinct, despite the many sculptural folds that charaterize the drapery in his early frescoes, a legacy from the classical-styldrapery of thirteenth century painting.

The concept of space evident at Assisi had been known to the ancient world, and lost in the Dark Ages. But it was not merely question of a new way of painting. The idea of reconstructing three dimensional space illusionistically on a two-dimensional surface restored importance to that reality perceived by the senses that has been lost in the intervening years, when the only true reality we considered to be that of the spiritual world. Giotto's reversal of the concept paralleled certain trends of thought, especially promined among Franciscan intellectuals, that were to culminate in the Nominalist philosophy of Giotto's English contemporary, William of Ockham.

Giotto's architectural settings are not merely a means of creating pictorial depth, but also a reflection of contemporary Italia architecture. At times they are reproductions of real buildings like the Palazzo Pubblico and the Temple of Minerva in the Piazza de Comune at Assisi, both of which appear in the Homage of a Simpa Man. The mosaic inlays which decorate the architectural structures in his Assisi frescoes, and which subsequently became commonplace is fourteenth century frescoes, are nothing more than reproductions of the Cosmati work made by Roman marble workers throughout man parts of central and southern Italy.

Giotto's capacity for renewing the art of painting by observin

ality through his own eyes becomes even more impressive if we nsider the number of Byzantine conventions which were then mly rooted in Italian painting. As prescribed by the Orthodox nurch Byzantine painting was based on the repetition of pre-exisnt models and on faithfulness to established formulas. For the chitectural setting of a sacred 'story' Italo-Byzantine painters sorted to stereotyped structures like the dome-shaped baldachin, idently of Eastern origin. Even in paintings of the Legend of St ancis, which was more or less a contemporary legend, and certainly of Oriental, the Berlinghieri and other thirteenth-century Tuscan asters had frequently used such pictorial cliches.

With Giotto's frescoes at Assisi, this tradition was discarded, gether with pictorial formulas of an abstract significance, intended reminders of a reality different from that of this world. This, which as still present in the art of Cimabue and the young Duccio, was nished by Giotto, and the painting of human beings regained a ore normal, earthly appearance, and a naturalness whose only mediate precedent can be found in French cathedral sculpture.

Christ's heavy body in the Santa Maria Novella Crucifix, which as soon to become a basic prototype (in 1301 Deodato Orlandi was ready copying it in his Crucifix in San Miniato al Tedesco), is of ch earthliness that some have considered it unworthy of being tributed to the sublime artist of the Arena Chapel frescoes. Yet the ork is so much in keeping with the ideas Giotto was developing at at time in his Assisi frescoes, that the figures of the mourning irgin and St John in the side panels are almost interchangeable with ose of Esau and Jacob in the scenes of the Isaac Legend. The two oups of figures have enough features in common for us to be ertain that they were conceived by the same artist: the wide, square noulders; the intense gaze (sorrowful, as befits the occasion, in the vo Florentine figures; slightly clouded by a melancholy reminiscent Cimabue in the Assisi figures); the solemnity and stiffness of titude; the many fine folds in the classicized clothing; the ears aped to resemble the handles of an amphora; and, in the figures of ne Virgin and Jacob, the nose flattened to form a sharp angle, the neek defined by the shallow cavity that begins at the nostrils, and ne high cheekbones. Ghiberti cites the Crucifix in Santa Maria Novella as a work of Giotto's and a document of 1312 records a Crucifixion by Giotto in the same church.

These figures also bear a striking resemblance to the two half-length figures of angels, one in Boville Ernica and the other in the Vatican Grottoes, which are the only remains of Giotto's most famous work: the mosaic of the *Navicella* (Christ walking on the water), designed for the facade of St Peter's in Rome, and completely remade during the reconstruction of the basilica, begun by Julius II in the sixteenth century. The similarity is apparent in the old-fashioned way of draping the cloak over one shoulder.

After the two scenes of the story of Isaac, the frescoes in the Upper Church at Assisi continue in the bay nearest the entrance. The work began, as was the custom in the vault, where the four Doctors of the Church are depicted, and probably proceeded along the upper walls in the large lunettes flanking the windows where scenes from the Old and New Testament are arranged on two levels. Of the Old Testament scenes, the two of Joseph (Joseph cast into the Pit by his Brothers and the Joseph and his Brethren) in the lower tier are still partially comprehensible, while there remains only a fragment of the scene above, the Death of Abel. The fragmentary New Testament scenes include Christ among the Doctors, the Baptism of Christ, the Lamentation and the Resurrection. This series is concluded on the entrance wall with the large scenes of the Ascension and the Pentecost, which are surmounted by roundels of busts of St Peter and St Paul, and surrounded by a series of full-length figures of Saints arranged in pairs on the soffit of the entrance arch. The saints stand within lovely mullioned shrines painted illusionistically using the same technique that was to be applied to the framings of the Legend of St Francis.

Since the frescoes in this series are not up to the standard of the two Isaac scenes, they are probably the work of the artists who later assisted Giotto in painting the Legend of St Francis. The difference is especially evident in the scenes of *Joseph and his Brethren* and the *Pentecost*, the vault fresco of *St Ambrose*, the bust of *St Paul*, many of the figures of saints, and the small busts of saints on the soffits of the two arches linking the vault to the side walls. But here, too, the treatment is faithful to the new vision that first appears in the Isaac Legend. Looking at these frescoes, one gets the impression that

cenes from the Old Testament.
ssisi, Upper Church.
Isaac Blessing Jacob.
Isaac Blessing Jacob (detail,
ebecca and Jacob).

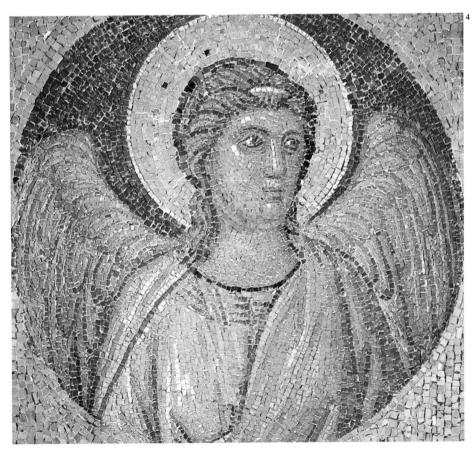

Boville Ernica, Church of San Pietro Ispano. . *Angel (mosaic)*.

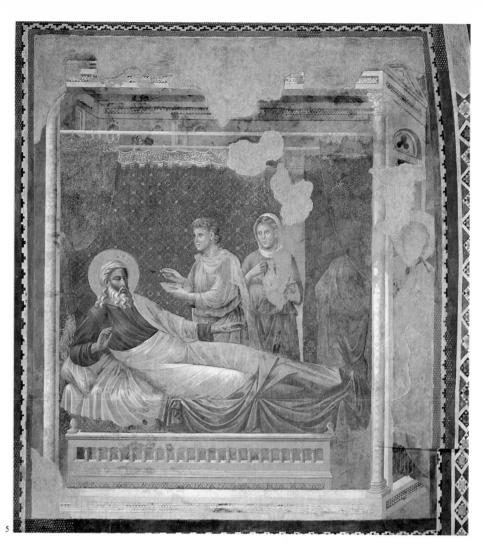

Scenes from the Old Testament. Assisi, Upper Church. 5. Isaac Rejecting Esau.

Florence, Santa Maria Novella. 6. Crucifix (detail, head of the Virgin). 7. Crucifix.

Giotto's ideas have been interpreted in a somewhat archaic manner, (especially in the fresco of *St Ambrose*), and in the apparent reluctance on the part of the painters to abandon abstract pictorial formulas of Byzantine origin (see the small busts of saints), a less convincing solidity of figure (see *Joseph and his Brethren*), and an excessive attention to detail in certain parts (see the figures in the *Pentecost*).

Yet most of the frescoes maintain a dramatic tension and pictorial incisiveness that places them on a level with the Isaac Legend scenes and the *Crucifix* in Santa Maria Novella. Certain aspects of these works are of a very high quality indeed: the intensity of expression of the young Christ among the Doctors; the solemn expression of grief in the *Lamentation*; the profound, concentrated gaze of St Peter in the roundel; the remarkable foreshortening of the sleeping soldier in the *Resurrection* (strongly reminiscent of the foreshortening used in the figure of the friar kissing the saint's hands in the *Death of St Francis*, in the Bardi Chapel in Santa Croce); the acolyte who writes at the saint's dictation in the fresco of *St Gregory*, (the same face, the same air of melancholy as in the figure of Jacob); the imposing composition of the *Ascension*, where Christ, who has Isaac's slender, tapering fingers, is borne aloft on a cloud which is both soft and yet strangely rock-like.

The frescoes of the entrance bay are so fragmentary that it is difficult to evaluate the innovations in composition and spatial experiments first seen in the Isaac legend scenes.

Nevertheless, a few words should be devoted to the *Doctors of the Church* which are in a good state of preservation. Each of the four learned men is accompanied by his acolyte, and above each pair is a bust of Christ, framed in a cloud. Following the model of Cimabue's four Evangelists in the vault above the altar, the various objects represented in each fresco are made to converge towards the vertex of the triangular field. It is almost as if the artist had attempted a kind

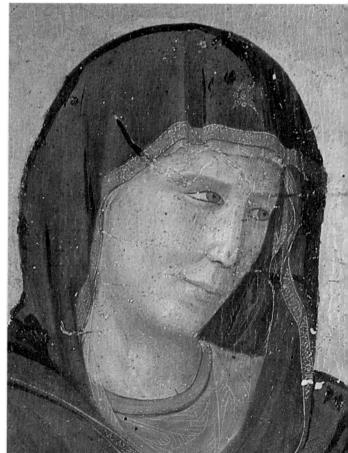

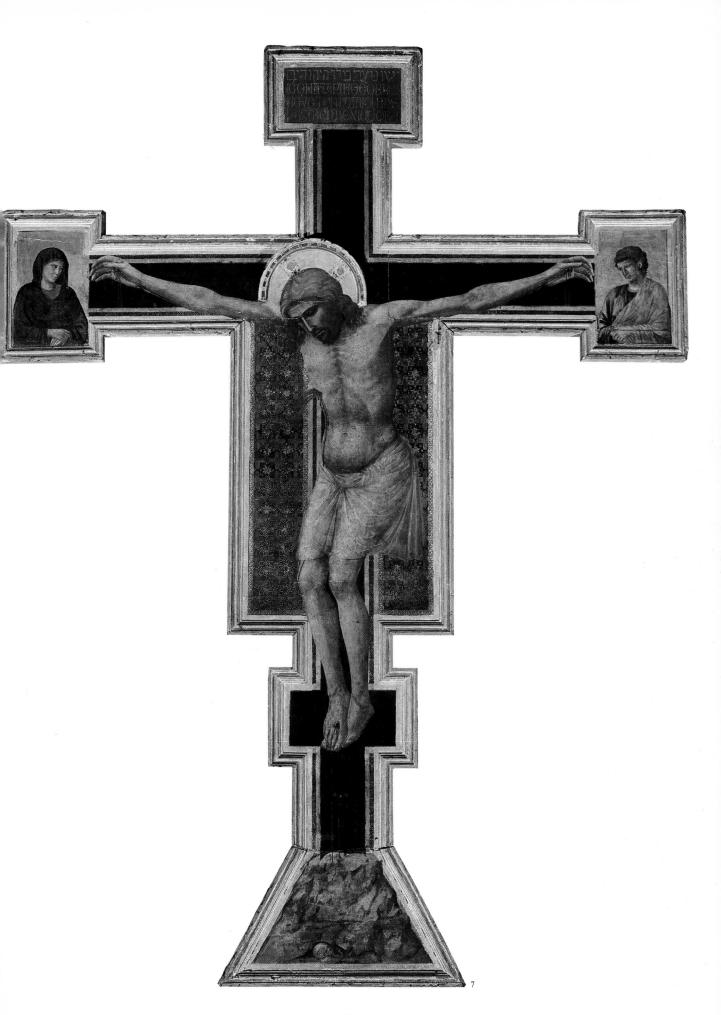

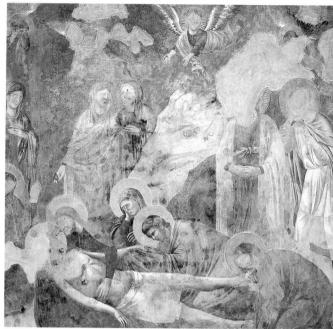

Scenes from the New Testament. Assisi, Upper Church. 8. Resurrection (detail).

9. Lamentation.

10. Lamentation (detail).

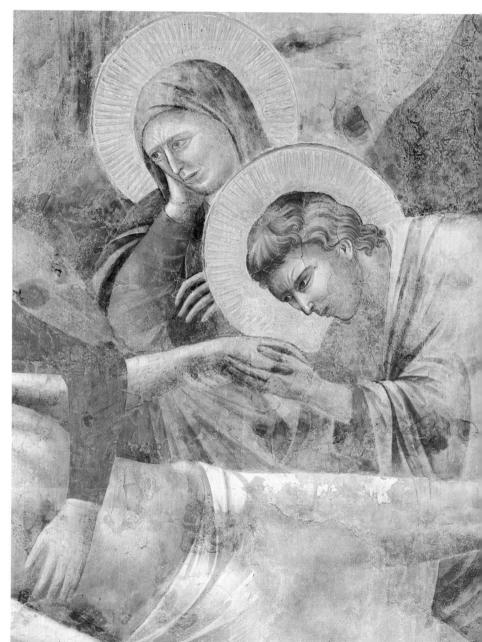

Soffit of the entrance arch. Assisi, Upper Church.

11. St Francis and St Clare.

Vault above the high altar. Assisi, Upper Church.
12. The Doctors of the Church.
13. The Doctors of the Church (detail, St Jerome).

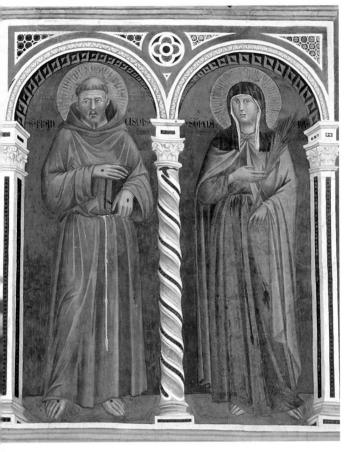

of view from below upwards, and therefore incorporated the convergence towards the vertex into the foreshortening.

The chief interest of these frescoes lies in the fact that they represent for the first time in the history of painting the polychrome effects of bright marble, inlaid with mosaic decorations and embellished with coloured moulding, which had been used on the facades of the most important churches in central and southern Italy, and in their furnishing—ambos, episcopal thrones, altars and tabernacles.

So great were Giotto's interest in physical reality and his capacity for expressing it in painting that even his wooden furniture assumes an amazing, almost *trompe-l'œil* tangibility. Some of the objects are depicted down to the last detail, as can be seen in the writing-desk of St Gregory's acolyte, and in the scroll on which he writes, where even the two eyelets in the paper are shown.

One is reminded of the panel painting, clearly the same Madonna and Child by Giotto described by Ghiberti, in the Church of San Giorgio alla Costa in Florence. The panel has been cut on both sides, but from what remains we can reconstruct the bright marble throne embellished with rose-coloured mouldings and strips of Cosmati work, terminating in a Gothic cusp edged with foliage-scrolls exactly like those on the aedicules of the Doctors of the Church at Assisi. Here, too, small details, such as the rings and cord by which the cloth is suspended from the throne, are rendered with great clarity. In this painting we find the same deliberate contrast of fragility and strength, of the delicately rendered minutiae of the supporting structure and the ponderous weight of the figures, that also characterizes the Ognissanti Madonna, now in the Uffizi. But let us return to Assisi, bearing in mind the image of the two elegant, slightly melancholy angels in the Florentine painting so that we can compare them with the figures in the Upper Church frescoes. Of particular interest is the angels' hair-style, consisting of wide coils

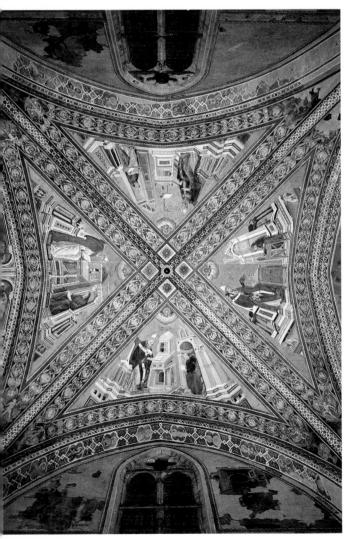

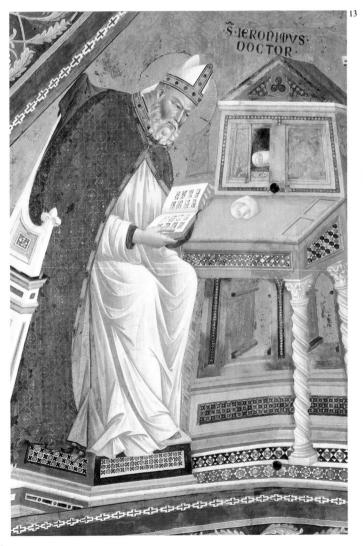

above the ears, and loose waves at the back, which is exactly like that of the old Isaac.

The decoration of the Upper Church was planned from the very beginning to conclude with the Legend of St Francis on the lower walls, which protrude slightly beyond the upper walls. The whole was conceived according to a scheme which incorporated both the iconographical and the decorative aspects of the frescoes. No representation in the Upper Church is duplicated, except for the Crucifixion, which appears among the scenes in the nave, and is repeated on either side on the east walls of the transept. In this case the repetition was intentional, and must have been planned from the beginning, as is demonstrated by the fact that the two scenes appear in the same position in the Lower Church, where the aim of the old thirteenth century decorations, destroyed when the side-chapels were built, was to establish parallels between the life of Christ and that of St Francis. This idea was repeated in the Upper Church with greater richness and with the inclusion of scenes from the Old Testament. At certain points the parallel becomes very evident; for instance, the Confirmation of the Rule appears below Isaac blessing Jacob, and the Death and Ascension of St Francis (who has just received the stigmata) below the Crucifixion.

Florence, San Giorgio alla Costa. 14. Madonna and Child.

Scenes from the New Testament. Assisi, Upper Church.

- 15. Pentecost.
- 16. Roundel of St Peter.
- 17. Roundel of St Paul.

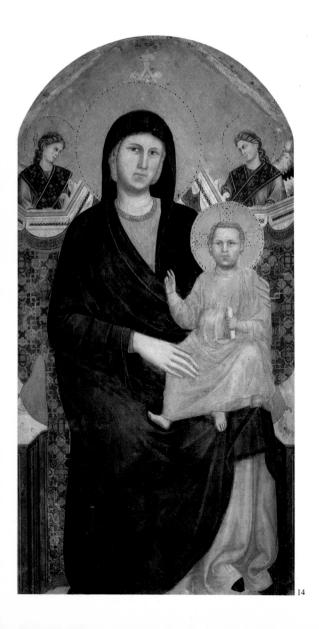

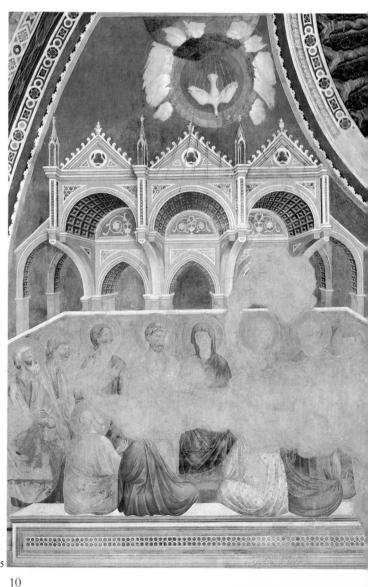

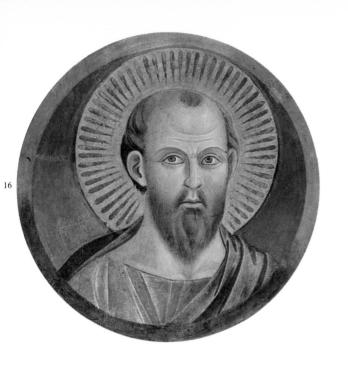

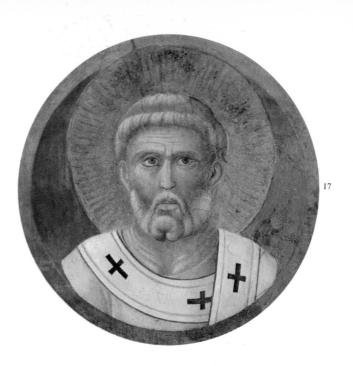

The Legend of St Francis. Assisi, Upper Church.

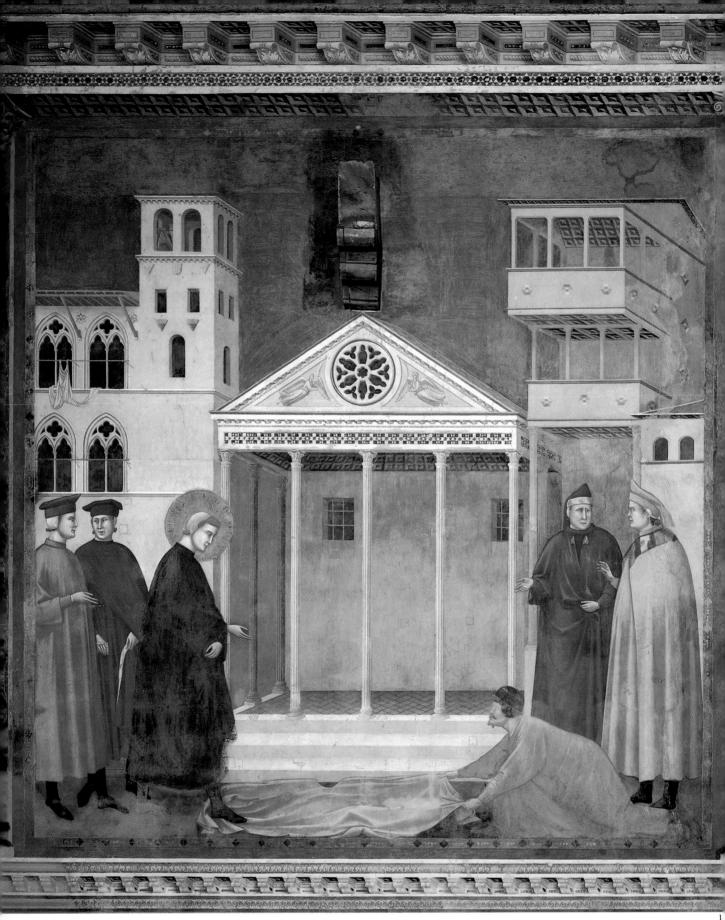

Scenes from the life of St Francis. Assisi, Upper Church. 18. Homage of a Simple Man. 19. St Francis giving his Mantle to a Poor Knight.

20. Dream of the Palace.

The Legend of St Francis

A strong argument for the idea of a general plan for the whole nave is provided by the decorative system, in which an impression of continuity is maintained in spite of the radical change in the pictorial conception which occurred in the course of the decoration. In fact, the decorative motif of the row of mock consoles which support the mock architrave at the top of the projecting wall where the Legend of St Francis appears had already been used for the same purpose by Cimabue in his frescoes in the transept. This fact alone suggests that the decoration of the church, which was begun at a time when the basilica of San Francesco was perhaps the most important in Christendom — the centre of the most widespread religious movement the West had known since the advent of Christianity — was carried out with few interruptions. And it might be reasonably supposed that the decoration of such an important church would not have been left incomplete for very long, nor the unsightly scaffolding employed in its decoration tolerated any longer than was necessary.

As for the part of the decoration carried out by Giotto, the motif of the mock consoles can be used as an indication of the order in which the Old and New Testament scenes and the Legend of St Francis were painted. We have already seen that Cimabue employed the same consoles in the frescoes in the transept, though his way of painting them was completely different from the way in which Giotto was to use them above the St Francis cycle. Cimabue's consoles are two-dimensional, and painted in inverted perspective, i.e. the side consoles are made to diverge — instead of converge, as they would appear to the eye - from the central console. The painted consoles above the Legend of St Francis correspond much more to visual reality since they are represented as solid objects and converge towards the central console. The row of consoles on the ribs of the vault of the Doctors of the Church was painted according to the system used by Cimabue, but in a small section of the upper walls, between the Joseph and his Brethren and the Pentecost, and between the Resurrection and the Ascension, the faked architecture is surmounted by a row of consoles painted in the same method Giotto was to use for those above the St Francis cycle. This is evidently a method that he worked out gradually as the decoration proceeded.

There is also another aspect to be considered. Work on the St Francis cycle began with *St Francis giving his Mantle to a Poor Knight*, the second of the twenty-eight scenes, while the first scene, the *Homage of a Simple Man*, was probably painted last. This is because the beam of the iconostasis, or rood screen, a piece of which is still visible, was to be inserted into the wall in the area occupied by the first scene. Evidently, it was only towards the end of the work that it was decided to fresco the first and last wall areas as well, painting them in such a way that the beam could be inserted into the neutral area of the blue background.

There is a remarkable difference between the first and second scenes of the cycle. In the Homage of a Simple Man the painting has become softer, the transitions of colour are more delicate, and the clothing has a very soft, velvety conistency which, especially in the case of the figure on the far right, already looks forward to the Arena Chapel frescoes. But St Francis giving his Mantle to a Poor Knight is still distinguished by a transparent, almost metallic colour which creates a granite effect in the rocks of the landscape. Moreover, the head of the young St. Francis in this fresco is closer to those of Esau, Jacob, St Gregory's acolyte, and the two mourners in the Santa Maria Novella *Crucifixion* than it is to the softer, more mature head of the saint in the *Homage of a Simple Man*. In short, there would appear to be less difference between Giotto's frescoes on the upper walls and the early works of the St. Francis cycle than there is between the first and last frescoes of the St Francis cycle. This suggests that as soon as they had finished the frescoes on the upper walls, Giotto and his team of painters began work on the Legend of St Francis, taking more time over it because there was a larger surface to cover, and because the work, being nearer the spectator, had to be carried out with greater care.

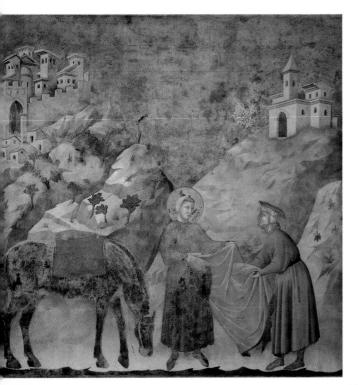

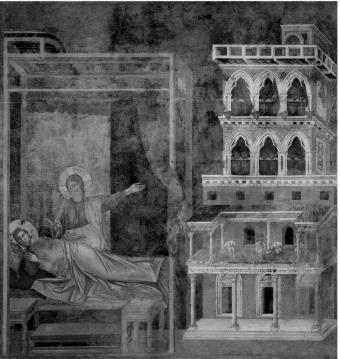

20

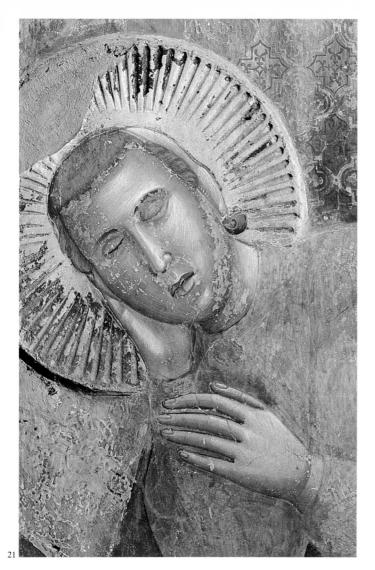

Scenes from the life of St Francis. Assisi, Upper Church.
21. Dream of the Palace (detail, sleeping St Francis).
22. Miracle of the Crucifix.

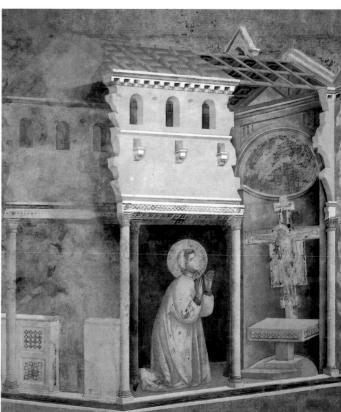

The execution of large parts of the twenty-eight scenes of the Legend of St Francis, especially the final ones, (for instance, the kneeling friars in the Confirmation, St Francis before the Sultan, some of the figures in the Institution of the Crib at Greccio) are doubtless of a somewhat lower standard than that one would expect from Giotto himself. But even though the contributions made by his assistants are sometimes so individual in their treatment that we can attempt to identify the individual artists (Memmo di Filippuccio? Master of the Crucifix of Montefalco? the St Cecilia Master? Marino da Perugia?), all the scenes, including the final ones, are distinguished by a unity of conception and a consistency of outlook found only in the work of Giotto. In fact, the works executed by these artists independently reveal that they never approached Giotto's level of achievement; the style of one painter is insufficiently articulated, another is over-expressive, yet another is over concerned with detail. Only one work bears comparison with these frescoes: the Stigmatization of St Francis in the Louvre. And it is signed by Giotto.

I have already dealt with the mock architectural framework, so beautifully depicted in its detail, surrounding the Legend of St Francis. Each bay is divided into three almost square panels, save for the bay nearest to the entrance, which has four compartments, and the facade wall, which has two sections higher than they are wide. The vanishing points are located in the centre of each bay, as is indicated by the disposition of the painted consoles. This, the most extensive of all St Francis cycles, and one which was to serve as a model for many years, consists of twenty-eight stories based on the official biography of the saint, St Bonaventure's Legenda Maior. Each scene has an accompanying explanatory inscription in Latin.

The scene of St Francis giving his Mantle to a Poor Knight, which, as was mentioned above, was the first to be painted, takes

place in the open air, at the foot of two rocky hills. The town perched on the hill on the left is Assisi; we can see its crenellated walls, the profile of its towers and roofs against the sky and the church of Sar Damiano outside the walls. Anyone who has had the opportunity to see hillside towns such as Cortona, Spello and Assisi from the plair below can fully understand the accuracy of this painting. A rocky landscape such as the one shown here, an inheritance from Byzantine painting, may have first appeared in Joseph cast into the Pit by hi. Brothers (as far as we can tell from what remains) or, more likely, in the Death of Abel, which has almost completely disappeared. It is a conception that was to be beautifully expressed in the Miracle of the Spring and Stigmatization of St Francis, and adopted by nearly all later painters up to the beginning of the fifteenth century. It was to be codified in the celebrated passage of Cennini's Trattato della Pittura, which was doubtless inspired by Giotto's principles: "If you want to paint natural-looking mountains, take some large jagged rocks, and paint them from nature, adding light and shade as reason dictates."

The beautifully rendered mantle in St Francis giving his Mantle to a Poor Knight is reminiscent of the blanket that covers the old patriarch's legs in Isaac blessing Jacob. The folds of this garment have such convincing thickness that it almost seems possible to insert a hand into them. In the next scene, the Dream of the Palace, the blanket that covers St Francis as he sleeps has a similar tangibility. The composition of this scene is very similar to that of the third fresce in the next bay, the Dream of Innocent III. The bedchambers in the two frescoes call to mind the scenes of Isaac, though the furnishing and architecture appear to be more in keeping with the style o Giotto's time. The two dreams are depicted very literally: the first dream is of a strange narrow palace in the Italian Gothic style, which

cenes from the life of St Francis. Assisi, Upper Church.

3. Renunciation of Worldly

4. Dream of Innocent III (detail, St rancis).

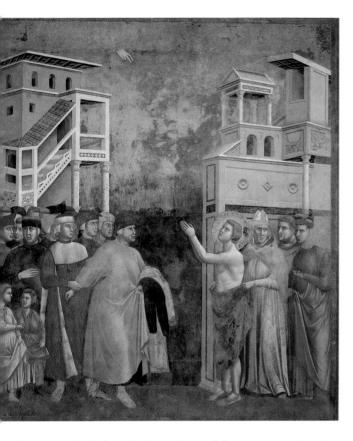

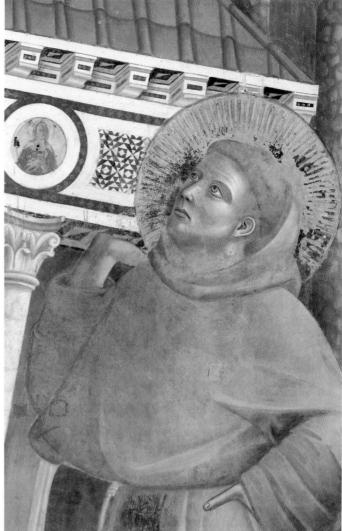

tands next to the bed as if it formed part of the sumptuous furnishngs of the chamber; the second is that of Innocent III. In his dream he Pope saw the Church upheld by the Franciscans. The painter howed St Francis literally propping up the Church of San Giovanni 1 Laterano as it appeared at that date, after Nicholas IV's restoration f 1290. The facial expression of the youthful St Francis as he upports the church is one of the most intense in the whole cycle.

As if they were intended to emphasize the personal and private ature of the saint's early life, these first scenes are very simple, and ontain few figures. This is especially evident in the Miracle of the *rucifix*, where there are only two basic elements, the dilapidated hurch — where we can see the crucifix on the altar — and the young t Francis. The church, set at an oblique angle, is shown with egments of the wall removed (like a broken vase) both to symbolise s state of moral decay and to enable us to see the interior with the peaking crucifix. St Francis is there symbolically rather than actually, ainted on a larger scale than the building.

This treatment of figure and architecture as independent elenents was to remain a feature of fourteenth-century painting, ecoming accentuated in the early fifteenth-century, and employed a deliberately unnaturalistic way in certain late Gothic works. This rait can also be seen in the painters of the Early Netherlandish chool; Jan Van Eyck's Virgin in a Church, in which the Virgin's lead is on a level with the capitals in the nave, is a typical example, nd one that can be compared to the Miracle of the Crucifix. The onception of a pictorial story as an agglomeration of separate inidents was to be greatly simplified in Giotto's later works, especially 1 the frescoes in the Bardi and Peruzzi chapels in Santa Croce. But it ook the rationalism of Brunelleschi, and the art of Donatello and lasaccio to do away with it completely.

The next scene gives us an opportunity to examine one of the most important of Giotto's innovations. Although the mastery of the method of representing the third dimension is of fundamental importance, there are other innovations which are no less significant to the development of Western painting. Among these must be included the use of eloquent gesture, the communication of strong emotions through attitude and facial expression. In the Renunciation of Worldly Goods, St Francis' father expresses his anger in his grimace, in his gesture of lifting the hem of his gown (as if he were about to dash at his son), and in his clenched fist; the effect is heightened by the gesture of his friend, who holds him back by the arm. Within the limits of the dignity and self-restraint that Giotto impresses on all his characters, the father's anger is expressed clearly and vividly.

St Francis preaching before Honorius III is one of the scenes of the Legend of St Francis in which gesture, attitude and facial expression are essential for the story, and in this respect it was to become a model for fourteenth-century painters. Although some have felt St Francis' gesture to be vulgar, it certainly was not considered coarse in Giotto's day — that lively way of indicating with the thumb was to reappear in such paintings as Pietro Lorenzetti's Virgin with St Francis and St John in the Lower Church of San Francesco. The prelates' gestures of meditation and wonder were to become extremely common in the course of the fourteenth century, but here they were total innovations.

Of the frescoes on the upper walls, it is the Lamentation which provides a rich display of profoundly expressive gestures of sorrow. This scene was usually depicted with the mourners screaming and thronging around the dead Christ, but here it becomes a masterly interpretation of grief reminiscent of the gestures of classical statuary.

The tone is livelier and less rhetorical in the scenes of sorrow of the St Francis cycle — the *Death of the Knight of Celano*, the *Death and Ascension of St Francis*, and *St Francis mourned by St Clare*. It should be remembered, however, that the Legend of St Francis tells the story of a man who had died within living memory, and deals with events that were almost contemporary, and men and women who lacked the legendary glory of Old and New Testament figures. There can be no doubt that the tone of the frescoes on the upper walls is more courtly and more solemn, as it was to be in the frescoes depicting the lives of the Virgin and Christ in the Arena Chapel at Padua, while in the Legend of St Francis the narrative tone is livelier and more direct to suit the characters.

At that time Dante was theorizing about various styles: a 'superior' style for tragedy, an 'inferior' style for comedy (his *Divine Comedy*), and the style 'of compassion' (*miserorum*) for elegy. The three styles had their respective idioms in an 'illustrious vernacular', a 'vernacular sometimes mediocre, sometimes humble', and an 'exclusively humble vernacular'. And when Jacopo Torriti included St Francis and St Anthony of Padua among the time-honoured saints of the Gospels in his apse mosaics in San Giovanni in Laterano and in Santa Maria Maggiore, he made them on a smaller scale than the others. Thus a lesser dignity was conferred on these new saints, who were felt to be intruders in such a solemn gathering, so much so that Boniface VIII planned to have them removed from the apse of San Giovanni in Laterano.

However unsatisfactory the execution of the figures may be, the Confirmation of the Rule and the St Francis preaching before Honorius III have the most organic spatial constructions of all the Upper Church frescoes. These scenes, which have a perfectly centralized view point, are two of the most outstanding examples of Giotto's conception of space as a cubic box open at the front. Notice how cleverly this space has been contrived. Our attention appears to be drawn to the upper part of each fresco, occupied by a series of protruding arches supported by sturdy consoles in the Confirmation of the Rule, and by the first surviving depiction of a cross vault in the history of Italian painting in the St Francis preaching before Honorius III. Such perfection of spatial construction is found only in the frescoes in the Arena Chapel, Padua, and the Bardi Chapel in Santa Croce, and those in the right transept of the Lower Church at Assisi, all of which are by Giotto.

Another noteworthy feature of the *Confirmation of the Rule* is the arrangement in depth of rows of kneeling friars behind St Francis. The first time anything of the kind appears in Italian painting is in the upper wall scene of the *Joseph and his Brethren*, where Joseph's brothers are always painted in horizontal rows parallel to the picture plane, as if they were standing on a series of progressively higher stools. Duccio still preferred this arrangement for the saints in his *Maestà* at Siena, while Simone Martini showed the rows of figures around the Virgin at a slightly oblique angle in his *Maestà* in the Palazzo Pubblico, Siena. The latter system had been introduced and systematically employed by Giotto, in perfect harmony with his conception of pictorial space.

The five scenes from The Vision of the Flaming Chariot to St Francis in Ecstasy are characterized by inferior workmanship, especially in the figures, though they do contain some remarkable inventions. The conception of the sleeping friars in the Vision of the Flaming Chariot is extraordinary; one of them is a more expressionistic version of the foreshortened soldier who sleeps with his head resting on the back of his hand in the upper wall scene of the Resurrection. Worthy of note in the Vision of the Thrones are the trompe-l'oeil clarity of the thrones suspended in space, and the depiction of the lamp in front of the altar, which has a cord for lowering it to replenish the oil. The Exorcism of the Demons at Arezzo is impressive for its depiction of a walled city, which is shown as a vertical mass of houses, towers, chimneys, roofs and roof terraces, all perceived as components of a single entity; the large church on the left, seen from the apse end, bears a strong resemblance to the Pieve di Santa Maria in Arezzo.

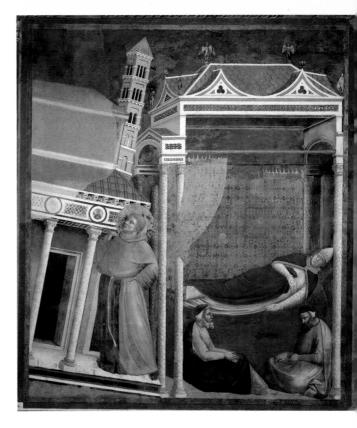

Scenes from the life of St Francis. Assisi, Upper Church.
25. Dream of Innocent III.
26. Confirmation of the Rule.
27. Exorcism of the Demons at Arezzo.

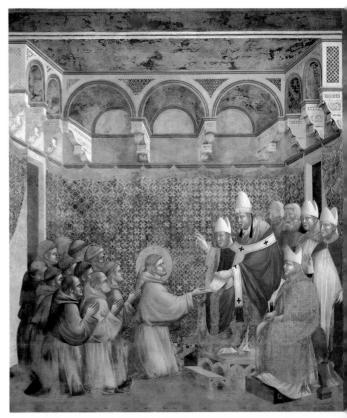

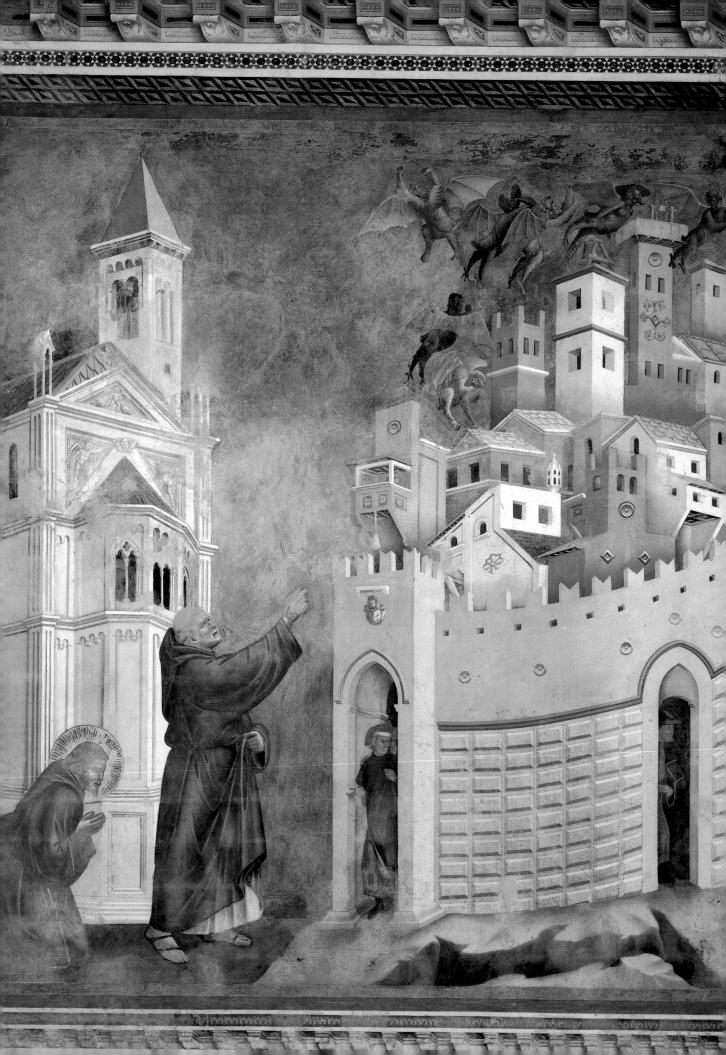

In many respects the Institution of the Crib at Greccio is one of the most interesting scenes in the cycle. It is set inside the church, viewed from the presbytery, in front of the transept that divides the presbytery from the nave. As women were not permitted to enter the presbytery, they are shown here looking on from the doorway of the transept. Everything in the church is seen from behind: the pulpit with its lighted candles; the table base of the lectern, on which is placed the antiphonary, or book of responses, of the four singing friars; the tabernacle in the style of Arnolfo di Cambio, decorated with Christmas garlands above the altar; and the cross, which leans towards the nave, its wooden backing and supporting structure clearly visible, something unheard-of at the time. In this scene, too, many of the figures have been executed somewhat mechanically by Giotto's assistants (especially the heads of the priests and of the acolytes standing behind them on the right), though the greatly expressive, lifelike figures of the singing friars are among the best in the whole St Francis cycle.

The two scenes on the entrance wall, the *Miracle of the Spring* and the *Sermon to the Birds*, the compositions in which the hand of Giotto is most apparent, are too famous to require a lengthy description. As Giotto's conception of the landscape in the former has already been mentioned, I shall merely point out the amazing precision with which the ass's packsaddle has been rendered. The *Sermon to the Birds*, on the other side of the doorway, provides an obvious foil for the *Miracle of the Spring*. The former is set on an open plain, where the figures are overshadowed by tall trees, while the vegetation in the latter consists of the wild scrub of the Mediterranean region, which must have been typical of the uncultivated uplands in Giotto's day.

Between these scenes, above the entrance, Giotto frescoed a large roundel of the *Virgin and Child* and two smaller roundels of angels. Despite the poor condition of the works, they are among the most beautiful in the Upper Church.

The four scenes in the first bay of the left wall deal with the last events in the saint's life, and are among the most fascinating in the cycle. Some of these have already been described, so it will be enough to point out the table in the *Death of the Knight of Celano*, which is covered with a lovely embroidered table-cloth, and laid with food, crockery and cutlery. Worthy of notice in *St Francis preaching before*

Honorius III, is the rich Cosmati work on the Pope's foot stool whose bright colours recall the vault of the Doctors. In the Apparition at Arles we are given a remarkable oblique view of the chapter-house, its back wall divided by three openings. The massive figures of the friars seen from behind anticipate certain features of the Paduan Lamentation. The variety of attitude among the friars the variety of colour of their habits, and the massive figure of S Anthony on the left, are among the most memorable aspects of this work. In the Stigmatization of St Francis, the rocks take on an almost phosphorescent luminosity on what is the darkest wall in the church

Giotto's authorship of some parts of the following frescoes is often questioned, and in the case of those in the last bay (usually attributed to the St Cecilia Master) denied completely. The fact that work was autograph mattered much less to the public of Giotto's dathan it does to us, accustomed as we are to assigning importance (and therefore a price) only to works, preferable signed, by an individual artist. In those days the artist worked with a team of assistants, and not every work that left his studio was entirely autograph, ever though it might have been signed by him. If the St Francis cycle and Assisi had borne a signature it would probably have been that of Giotto, despite the likelihood that his assistants played a key role in the execution.

The final frescoes have a greater affinity with the overall cycle than with the works of other painters who have been suggested a Giotto's assistants. Even the last three scenes have very little rearelation to the punctilious gothicism with which the St Cecilia Maste expresses himself in the painting, now in the Uffizi, from which he takes his name. The have much more in common with the other frescoes of the St Francis cycle, a fact we can more readily acknowledge if we admit that some development was inevitable in the cours of the execution of such a complex work.

No one can deny the greatness of certain parts of the frescoes in the second bay of the left wall, such as the beautiful angels flanking those bearing the saint's soul to paradise in the *Death and Ascensio of St Francis*. The setting of the *Verification of the Stigmata* inside the church, where the three icons — of the Virgin, the Crucifix and S Michael — on the rood screen are shown leaning forward, and the curved wall of the apse is shown in the background, is a conception found only in the *Institution of the Crib at Greccio*. In *St Franci*

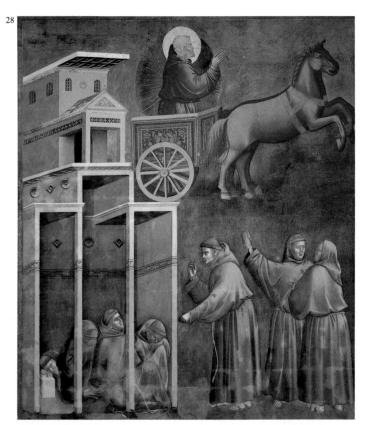

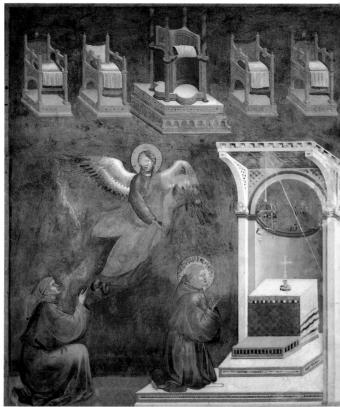

cenes from the life of St cancis. Assisi, Upper hurch.

8. Vision of the Flaming hariot.

9. Vision of the Thrones.

). St Francis before the eltan (Trial by Fire).

1. Ecstasy of St Francis.

2. Institution of the Crib at reccio.

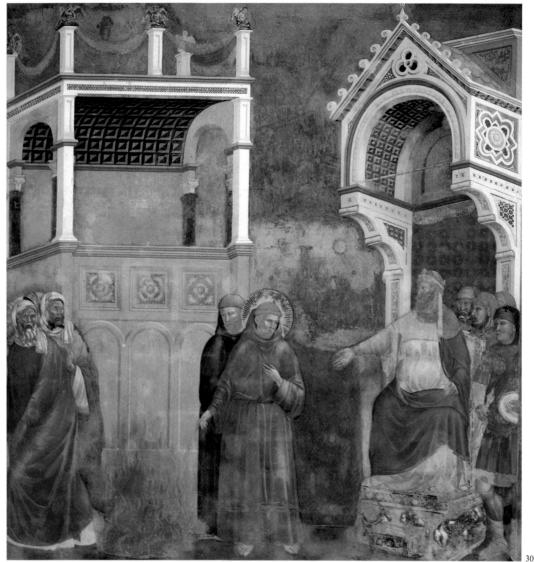

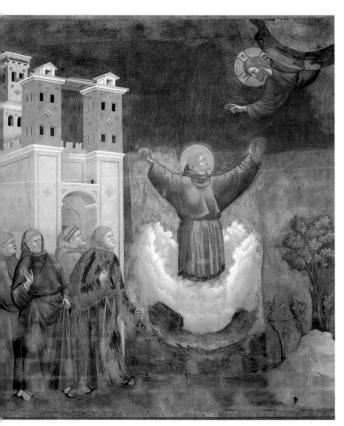

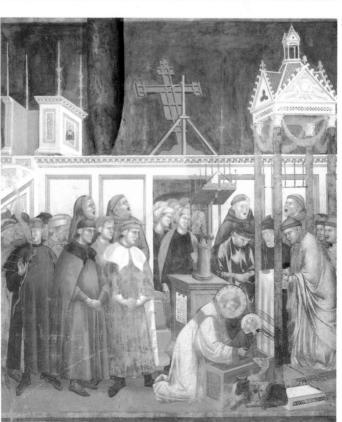

32

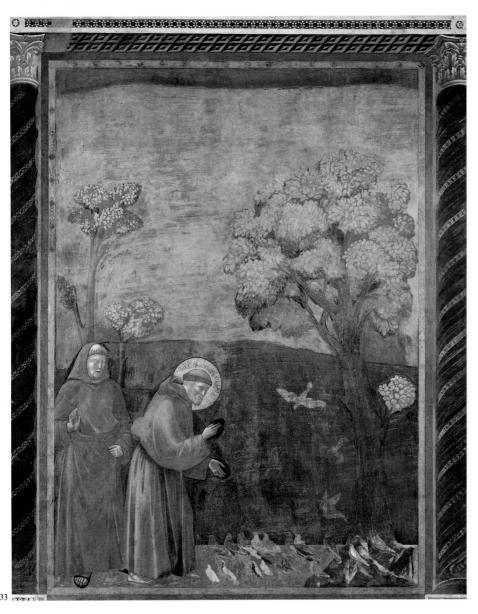

Scenes from the life of St Francis Assisi, Upper Church. 33. Sermon to the Birds.

34. Death of the Knight of Celan 35. St. Francis preaching before Honorius III. 36. Miracle of the Spring.

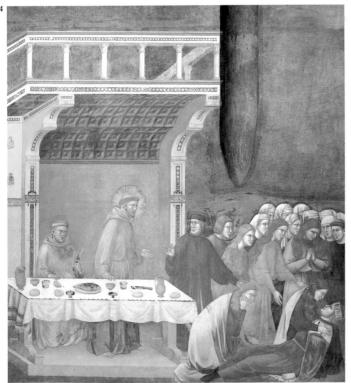

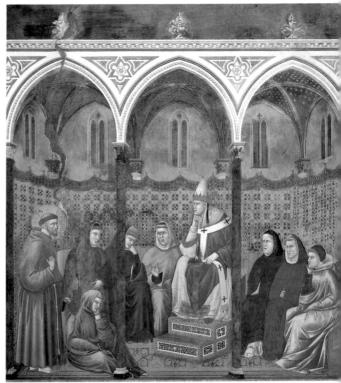

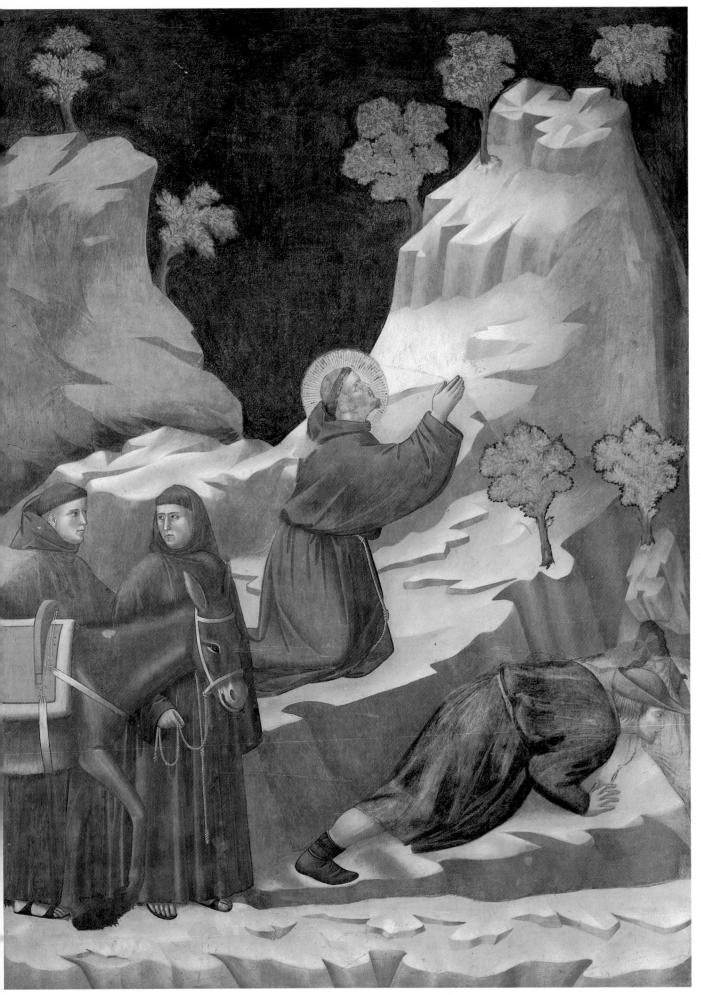

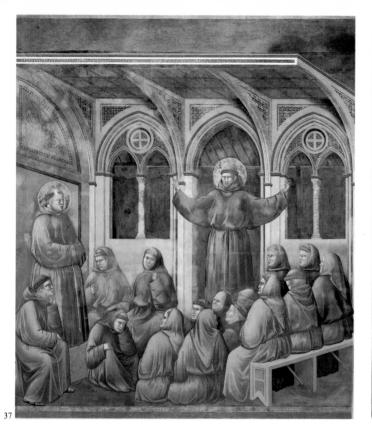

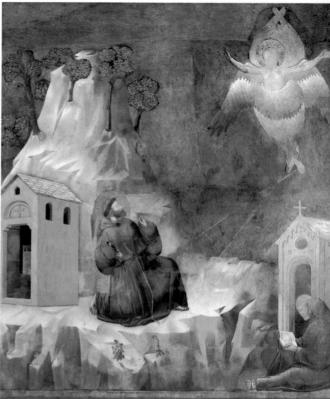

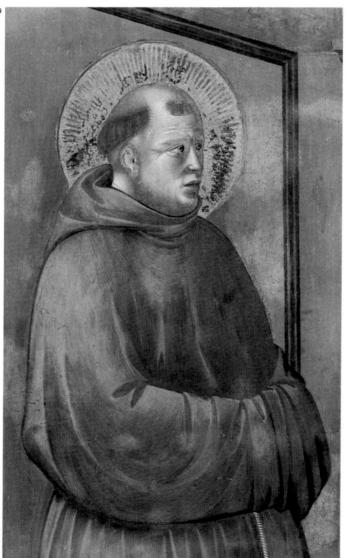

mourned by St Clare, in a better state of preservation, the facade of all Italian Gothic church is shown in the background, one of the first representations of its kind, decorated not only with marble and Cosmati work, but also with sculpture in high relief.

This and the next scene, the Canonization of St Francis, in which, despite its damaged condition, we can still perceive the splendid arrangement of the group of onlookers, lead naturally to a consideration of the style of dress Giotto adopted for his lay figures both male and female — a consideration which can also be extended to other scenes such as the Homage of a Simple Man and the Renunciation of Worldly Goods. He evidently thought it incongruous to use, as the Berlinghieri had done, the semi-classical dres customary for biblical scenes in representations of events that were almost contemporary. He therefore dressed his lay figures in con temporary clothing, just as he had made the buildings in the scenes reflect contemporary architecture. This idea was so successful that it inspired artists of the next two centuries to introduce figures in contemporary dress into their works frequently, even when representing events that were not contemporary. In considering the stylistic differences between the upper wall frescoes and the Legend of St Francis (or between the latter and the Paduan frescoes), we should bear in mind the realistic effect created by the use of contemporary dress.

Giotto was not the first to use contemporary dress: an anonymous artist had already done so in the painting of *St Clare*, dated 1283, in the church of the same name at Assisi. In this painting the lay figures in the small lateral scenes are dressed in what is unmistakably contemporary clothing. This style of dress, in many respects similar to that of the lay figures in the St Francis cycle, appears antiquated in comparison to the style of clothing depicted in the Arena Chapel frescoes. We must therefore conclude that the Assisi frescoes were painted much earlier than the Paduan ones.

The *Dream of Gregory IX* is distinguished by yet another remarkable representation of space. The scene is set in a well-proportioned room akin to those in the *Confirmation of the Rule* and the *St Francis preaching before Honorius III*. However, the fact that the spatial construction is no longer perfectly centralized constitutes a step towards the artist's later treatment of interiors. Of special interest here is the strong definition of the curtain suspended from the ceiling, which heightens the credibility of the spatial setting.

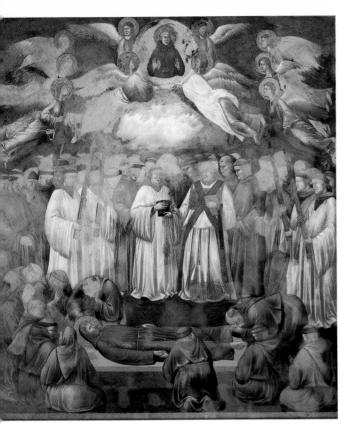

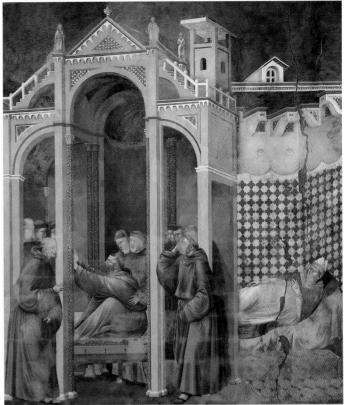

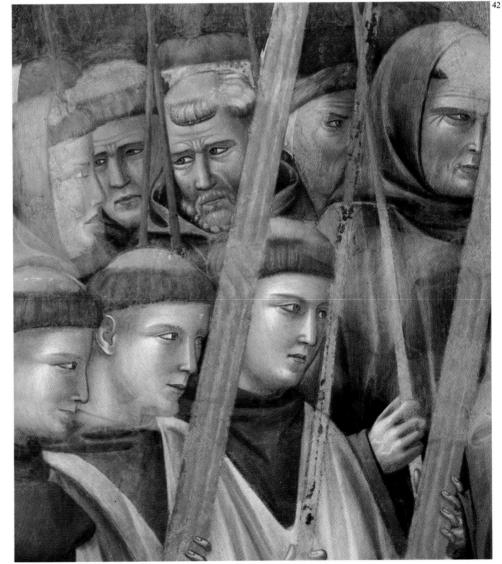

cenes from the life of St Francis. Assisi, Upper Church.
37. Apparition at Arles.
38. Stigmatization of St Francis.
39. Apparition at Arles (detail, St Antony).
40. Death and Ascension of St

Francis. 11. Apparition to Fra Agostino and o Bishop Guido of Arezzo.

12. Verification of the Stigmata 'detail).

The final scenes of the story — the Healing of the Man of Ilerda, the Confession of the Woman of Benevento, and the Liberation of Peter the Heretic — are characterized by an extreme delicacy of architectural structure, and slender, elongated figures. Yet parts of these works are of a very high quality, and comparable to the work of Giotto himself. This is true of the beautiful secondary episode of St Francis kneeling before Christ in the upper left-hand corner of the Confession of the Woman of Benevento, and of the delicate, fictive bas-reliefs on the round tower, inspired by Trajan's Column, on the right in the Liberation of Peter the Heretic. Moreover, the figure of the prisoner, a man named Pietro d'Assisi, anticipates certain physical types which appear in the Arena Chapel frescoes — for instance, the bearded man kneeling on the far left in the Prayer of the Suitors.

The development towards the softer effects characteristic of the Paduan frescoes has already been mentioned in connection with the Homage of a Simple Man, which is the first scene of the story, although the last to be executed. It has even been suggested that these final works were painted after the Arena Chapel frescoes, though all we have to do to exclude this possibility is to consider one detail — the profile. From a strictly naturalistic point of view the profiles in the St Francis cycle, including the final scenes, appear to be imperfectly realised. By contrast, the profiles in the Paduan frescoes are perfectly convincing, and, moreover, they are used to create some of the most dramatic moments in the narrative, as can be seen in the Betrayal of Christ, where the profiles of Christ and Judas are juxtaposed in the centre of the scene.

From the fourth century to the end of the thirteenth century sacred and important figures were invariably shown frontally. As a result, the use of the profile, which was reserved for representations of evil or marginal figures, became less frequent as time passed. To indicate that one figure was addressing another, the artist would merely incline one head, still seen in full face, towards another. Because of this convention, the artist's capacity for 'seeing' and representing the profile gradually diminished, as is demonstrated by the few works in which it was employed. The presence of this 'defect', like that of the archaic form of the 'angelic spirits', in the Legend of St Francis provides fresh proof of the fact that the Assisi frescoes pre-date those in the Arena Chapel.

The Assisi frescoes would seem to belong to an early stage in Giotto's career, when he and his workshop were still attempting to assimilate the Gothic innovations which were invading the Italian visual arts. If this is true, then the delicacy of the architectural structures and the elongation of the figures in the final scenes of the St Francis cycle may also justify suggestions that the St Cecilia Master worked on them. These Gothic elements, which also appear in the predella scenes of the Louvre *Stigmatization of St Francis*, signed by Giotto, go back to the same period in which Duccio di Buoninsegna was approaching the mature Gothic style of his late works. The great Sienese goldsmith Guccio di Mannaia, craftsman of the chalice donated by Nicholas IV to the Franciscan basilica between 1288 and 1292, was also an early exponent of the French Gothic style in central Italy.

If we consider the St Francis cycle as a whole, we are forced to admit that Giotto's interpretation of the famous saint is not particularly mystical: St Francis is a pious and devout figure, yet solid and earthly, far removed from the ascetic saint in earlier thirteenth century paintings. The objects in these frescoes have been expressed in such concrete form that even the metaphysical episodes seem to have been brought within the sphere of everyday experience.

The fact that this cycle served for so long as a model for the representation of the saint's life is probably due to the dominance of the more worldly interpretation of St Francis' teaching of the 'Conventual' faction both in the papacy and within the Franciscan order itself. It was an interpretation particularly agreeable to the rich Roman Curia, and in keeping with the interests of the new middle class which had control of the main cities of central Italy.

The 'spirituals', the opposing faction in the order, wished to return to the simple ascetic life of poverty demanded by St Francis himself.

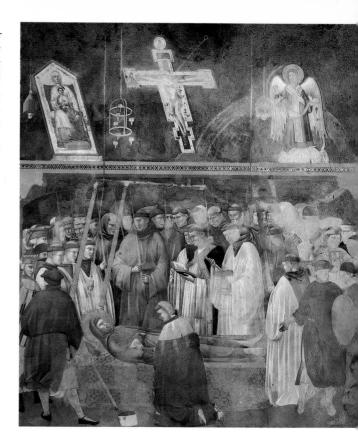

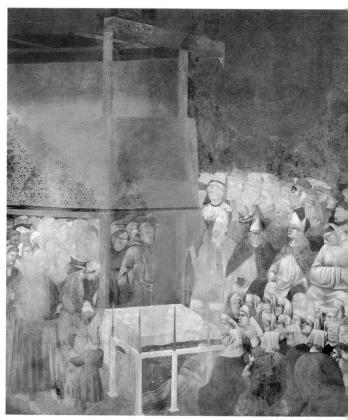

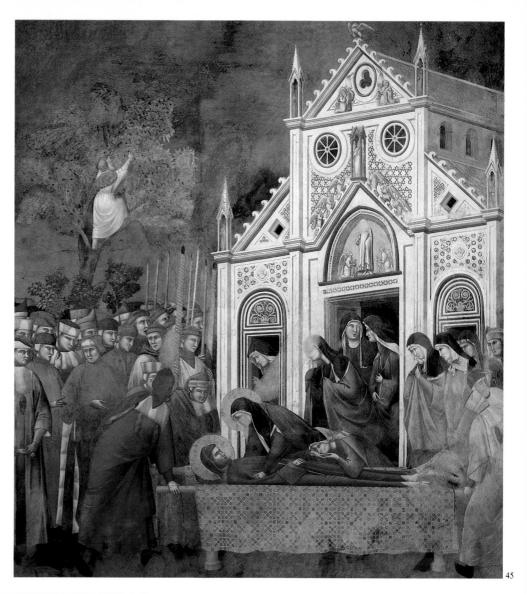

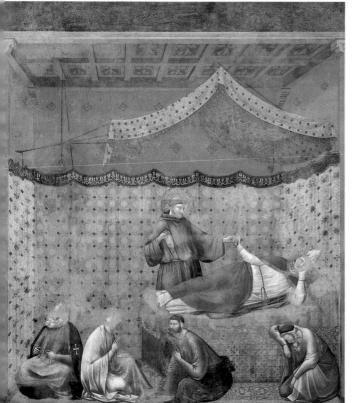

Scenes from the life of St Francis. Assisi, Upper Church.

43. Verification of the Stigmata.

44. Canonization of St Francis.

45. St Francis mourned by St Clare.

46. Dream of Gregory IX.

I have already touched upon the Louvre panel with the Stigmatization of St Francis, signed by Giotto and made for the Church of San Francesco at Pisa. The main scene and the three smaller scenes of the predella - the Dream of Innocent III, the Confirmation of the Rule, and the Sermon to the Birds — are obvious variations on the theme of the Assisi frescoes. Critics have tended to concentrate on the evident iconographical similarity of the two groups, and to pay much less attention to their equally evident stylistic affinities. What is most interesting to note in this work is the refined Gothic elegance, evident in the elongated figures of the predella scenes. The panel is stylistically close to the last Assisi scenes, and was the point of departure for the style of Florentine artists such as the St Cecilia Master, who, however, never achieved the degree of spatial coherence shown by Giotto here. It is this signed work, even more than the remains of the Navicella mosaic, which constitutes the most important proof of Giotto's authorship of the Assisi frescoes.

The Badia Polyptych (Uffizi, Florence), which was recorded by Ghiberti, and discovered some time ago in the Church of Santa

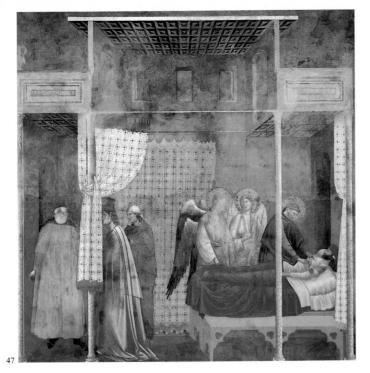

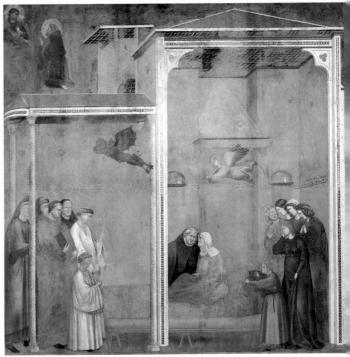

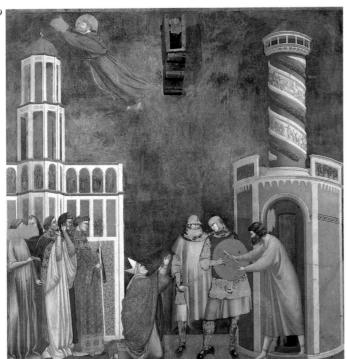

Croce, must have been painted in about the same period. In spite of the very poor condition of the work, we can still clearly perceive the solemnity of treatment which Giotto reserved for these saints. The dignified row of the half-length figures in the five panels, and the rhythmical repetition of the name-plaque on the gold ground above their heads were to make this work one of the artist's masterpieces. The Virgin recalls the Virgin in the roundel above the entrance of the Upper Church at Assisi.

Giotto's stay in Rimini, which was recorded by contemporary chroniclers must have preceded the decoration of the Arena Chapel at Padua. The precocious flowering of a Riminese school of painting clearly inspired by his art bears witness to this; in addition, the Rimini school appears to reflect a stage in Giotto's development close to his work at Assisi. The Rimini school has nothing in common with the Paduan frescoes.

Direct evidence of his having worked at Rimini is provided by the *Crucifix* in the Tempio Malatestiano in Rimini, which, unfortunately, has lost the panels once attached to the cross-limb and apex (one of these, a painting of *God the Father*, has been found in a private collection in England). It is a nobler version of the Santa Maria Novella *Crucifix* (also better preserved), already showing tendecies of the artist's mature treatment of the subject. However, its pronounced sculptural emphasis and physiognomical definition link it to somewhat earlier works such as the *Badia Polyptych* and the *Stigmatization of St Francis* in the Louvre.

Scenes from the life of St Francis. Assisi, Upper Church.

47. Healing of the Man of Ilerda. 48. Confession of the Woman of

Benevento.

49. Liberation of Peter the Heretic.

Paris, Louvre.

50. Stigmatization of St Francis.

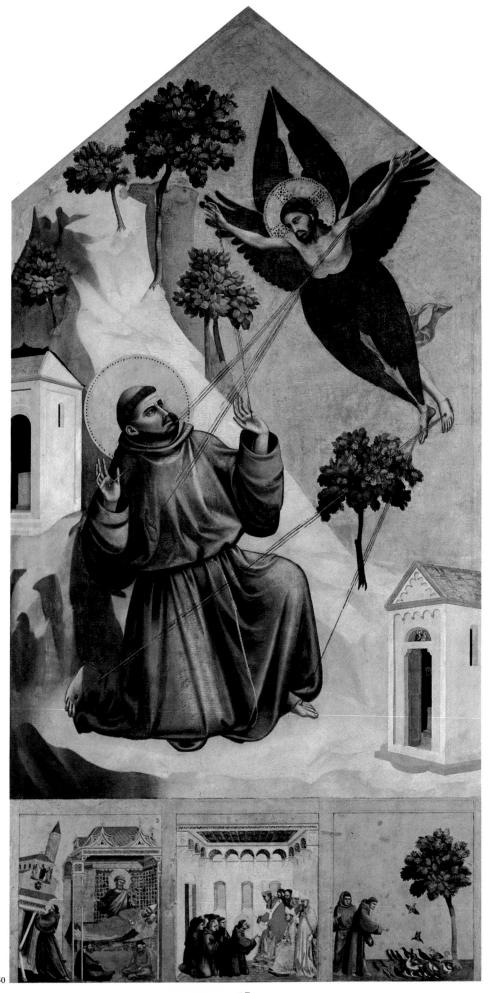

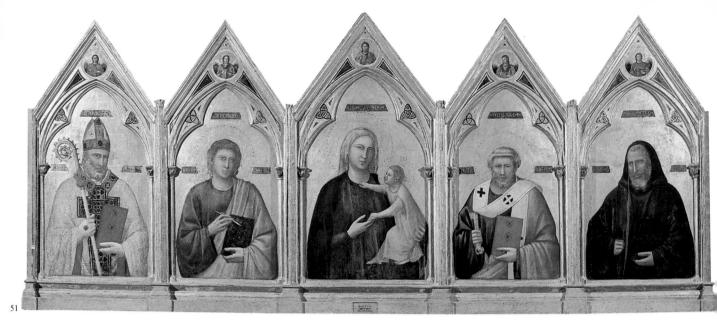

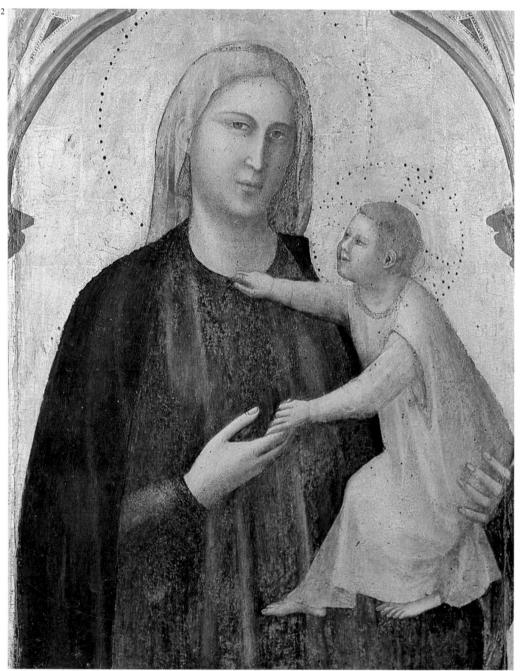

Florence, Uffizi. 51. Badia Polyptych. 52. Badia Polyptych (detail, Madonna and Child).

Rimini, Tempio Malatestiano 53. Crucifix.

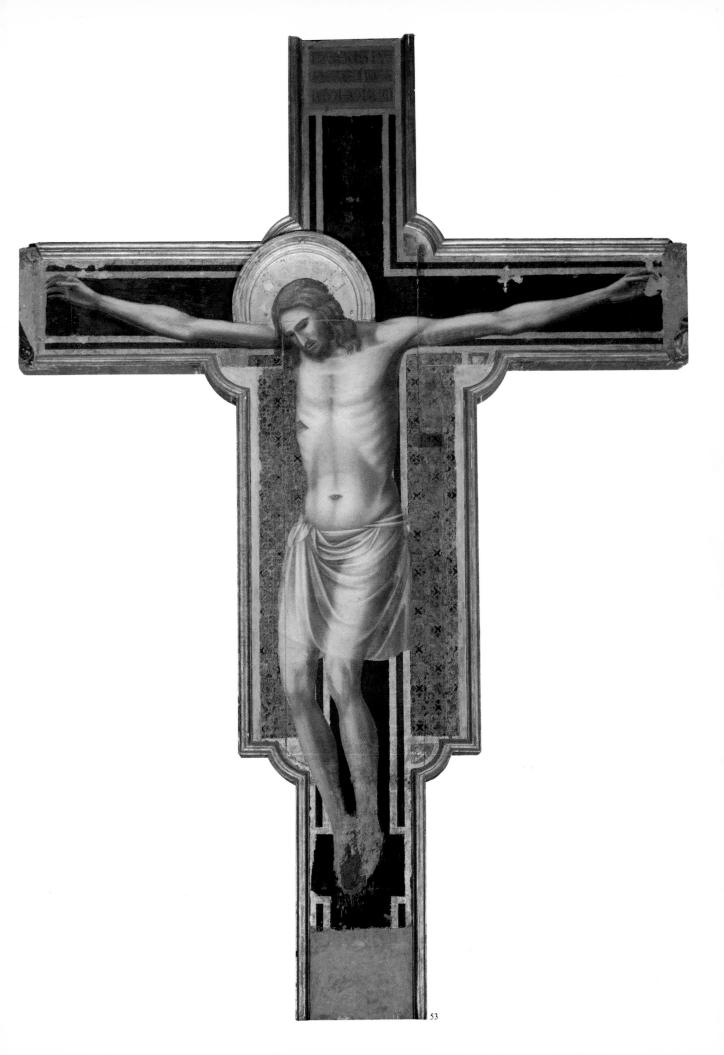

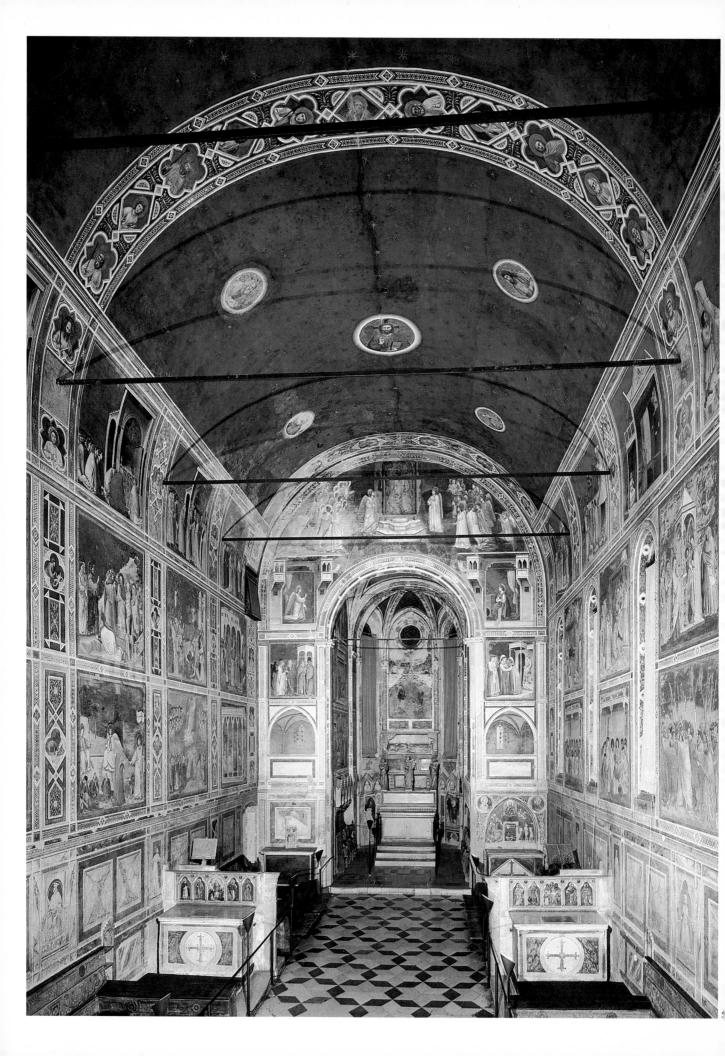

The Arena Chapel

The fresco decorations in the Arena Chapel at Padua have long been considered the greatest of Giotto's works, and one of the major urning points in the history of European painting. He was probably about forty years old when he began work on the chapel.

His Paduan patron, Enrico Scrovegni, was a wealthy, politically imbitious merchant who in 1300 had acquired the ruins of the old Roman arena at Padua as a site for his palace and adjoining chapel. Although existing documents are somewhat vague on the subject, it eems that the chapel was built and consecrated between 1303 and 1305. The date of the frescoes is not certain and is variously placed between 1304 to 1312/13, although a date of about 1305 would appear to be the most acceptable to the present author.

Owing to the small size of the chapel, lit by six windows on the ight wall, Giotto had at his disposal a wall-space that was both estricted and asymmetrical. In order to carry out the extensive conographical scheme, he took as his point of departure the areas between the windows, planning to depict in each of these two scenes one above the other. Using this as the basic unit of measure, he

livided up the walls of the chapel into panels.

The scenes on the walls are arranged in four tiers, and are urrounded by a framework that seems to form part of the architecture of the chapel. However, the framing is less emphasized than that of the Legend of St Francis, which is on one level, since exaggerated projections would have been unsuitable given the modest proportions of the Paduan chapel. Furthermore, the mock projections of the Assisi framings had been suggested by the real projection of the lower walls, whereas the walls of the Arena Chapel are perfectly flat. The scenes are separated vertically by wide, mock marble bands which are richly decorated with Cosmati work, and relieved by small, lobed panels containing representations of minor figures.

A significant innovation is the dado painted to imitate veined marble, and topped by a slightly projecting cornice, which, as at Assisi, is supported by a row of tiny consoles. Between the panels of nock marble are small monochrome frescoes imitating sculptural eliefs, the Seven Virtues and the Seven Vices. These were also shown on Giotto's Campanile. The feigned monochrome reliefs gave rise to 1 kind of fresco decoration that was to flourish in the fifteenth and sixteenth centuries (the most famous examples are the frescoes by Paolo Uccello in the Green cloister of Santa Croce, and those by Andrea del Sarto in the Cloister of the Scalzo, both in Florence). A parallel development can be seen in the fictive statues that Flemish painters included in the side panels of their altar pieces, beginning with Jan Van Eyck's polyptych of the Adoration of the Lamb.

An illusionism even more daring than that at Assisi is found in the frescoes flanking the chancel arch, just above the dado. Instead of 'stories', Giotto painted two views of the interiors of what appear to be sacristries or a choir, in perfect perspective. The effect is so realistic that we feel we are looking into actual rooms. Our gaze moves beyond the ogival arch to the cross-vault of each room, and thence to the Gothic mullioned window. In front of the window a lamp hangs from the ceiling by a rope, at the end of which is a small ring for raising and lowering the lamp (as in the Vision of the Thrones). The sky visible through the window is not the abstract blue of the background of the frescoes, but a much lighter blue clearly intended to represent the real sky, something quite exceptional for its time. That the two symmetrical chapels appear to have approximately the same vanishing point is an astonishing anticipation of the fifteenthcentury perspective system. Though their significance was once ignored, these small scenes are now recognized as an extremely important phase in the development of Giotto's conception of pictorial space.

Because the chapel is relatively small, and the right hand wall is interrupted by the windows, Giotto had to divide the wall surface into smaller panels than those at Assisi (the Paduan frescoes measure 200 x 185 cm, those at Assisi 270 x 230 cm). This explains the different relation in size of the figures to the panels and to the space that encloses them, since the figures in a fresco had to be as close as possible to lifesize. It is also one of the reasons the Paduan frescoes acquired that extraordinary concentration and pictorial unity so appreciated today, and a possible explanation for the unusually

stocky proportions of the figures.

Compared with the Assisi frescoes, the painting has become softer; the softer modelling gives the figures and objects an amplified volume. All harshness has been eliminated. The figures' gestures maintain an equilibrium between the *gravitas* of the antique and the gracefulness of French Gothic art. The narrative tone is solemn and elevated, yet relaxed and serene. The most important and most dignified figures have a majestic air, an expression of conviction, and a profound, concentrated gaze, yet they are warm and reassuringly human.

However, the scenes are not made up exclusively of prestigious characters; there is a supporting cast of minor characters whose lesser dignity is invariably emphasised by the expressiveness of their facial features and lively attitudes (in addition to their style of dress). We need only observe the faces of the servants waiting to pour the wine in the *Marriage at Cana*, or of Christ's torturers in the scenes of the Passion which are close to caricatures; or the smiles of St Anne's companions in the *Meeting at the Golden Gate*, or the bustling mid-wives in the *Birth of the Virgin*.

This more prosaic tone characterizes the personifications of the Virtues and Vices, in which the more mundane atmosphere is accentuated by the use of contemporary dress. In this respect the Virtues and Vices bear the same relation to the other frescoes in the chapel as the Legend of St Francis does to the frescoes on the upper walls of the Upper Church. It is not mere coincidence that the extent of Giotto's intervention in the Virtues and Vices has also been the subject of controversy, while the sublime tone of the stories of Mary and Christ has often led critics to overlook the weakness of certain parts, such as some of the marginal figures in the frescoes in the upper tiers (for instance, the three figures on the far right and the shepherd on the left in the *Meeting at the Golden Gate*, clearly executed by his less skilful assistants).

Padua, Arena Chapel. 54. View towards the altar. Let us now take a closer look at the frescoes, following the sequence of the narrative, and pausing to examine some of them in detail. We begin with the six scenes of Joachim and Anne in the top tier on the right wall. They tell of how Joachim was expelled from the temple because of his childlessness, how the angel appeared to Anne with the news that she would bear a child, how Joachim made a sacrificial offering that was favourably received by God, and of the angel appearing to him in a dream with the announcement of the coming birth of Mary; the series concludes with Joachim's return to Jerusalem, where he meets his wife Anne at the Golden Gate, and Mary is conceived in the kiss that Anne bestows on her elderly husband. This is a story with a happy ending, and with a quiet, pastoral atmosphere suggested by the rocky landscape and the shepherds with their sheep, whose soft, lifelike fleece has been meticulously rendered.

If we compare these scenes with the Assisi frescoes, we notice that here the space is more confined, the figures take up more room and that the architectural settings have been limited to a single structure in almost every scene, necessary for the telling of the story. Although all the scenes have their memorable aspects, one in particular, the *Annunciation to St Anne*, is well worth considering in detail.

St Anne's house consists of a bare framework that is intended to indicate an actual house. It has been given the same concreteness as the buildings in the Assisi frescoes, but since it is the only one in the scene it acquires greater prominence and clarity. It is a symbolic house, and as such decidedly small for its inhabitants, as is demonstrated by the small window. But it is just this lack of room that underlines its concreteness and depth. The interior and furnishings of Anne's room are so beautifully described that their only counterparts are those in some of the Assisi frescoes. The only witness to the event is the servant, who sits out on the porch, spinning; the skirt of her dress is stretched between her knees, creating deep folds that heighten the actuality of her form. Her dress has the same tangibility

as the cloak given away by St Francis in one of the scenes at Assist though it has been modified by a softer, thicker application of pigment.

The following six scenes on the opposite wall show the Birth of the Virgin, the Presentation of the Virgin in the Temple, and the four episodes pertaining to her marriage: the Rods brought to the Temple the Prayer of the Suitors, the Marriage of the Virgin and the Wedding Procession. This series also remains faithful to the principle of the single architectural structure. St Anne's house in the Birth of the Virgin is a repetition of that in the Annunciation to St Anne. The Presentation of the Virgin takes place in the same building as that in the scene of the Expulsion of Joachim from the Temple, but viewed from the opposite side. The temple in the Marriage of the Virgin appears three times in the series. The kneeling figures in the Prayer of the Suitors are seen from the side or from behind, and display that massiveness so typical of Giotto's Paduan period, an effect obtained by simplifying drapery and anatomy to the extent that the bodie appear to be perfectly solid.

The lunette above the chancel arch and the areas on either side of it, the most conspicuous wall surface in the chapel, is occupied by the *Annunciation*, the event to which the chapel was dedicated. It the upper section God the Father enthroned is painted on a badly preserved panel which also serves as a door. The striking mosaid decorations on the steps of the throne, which are painted in fresco call to mind the Assisi frescoes, especially the *Doctors of the Church*. The group of angels round the throne is so skilfully arranged that we are given the impression that even Heaven has depth. They calmly move about, play their instruments, sing, and take each other by the

Scenes from the life of Joachim. Padua, Arena Chapel. 55. Expulsion of Joachim from the Temple.

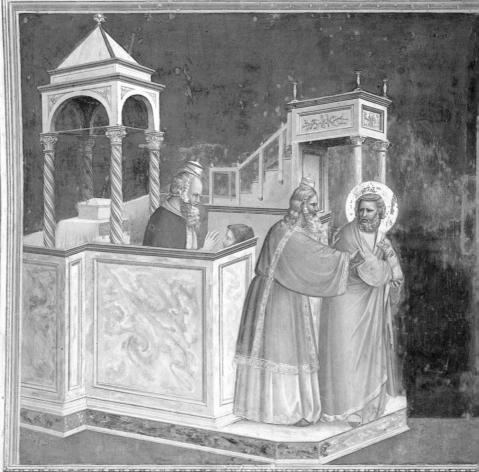

nd as if they were about to dance. This extraordinary conception ticipates by more than a century Fra Angelico's treatment of radise.

The Annunciation takes place in the lower section of the fresco, the two spandrels flanking the chancel arch. Each of the two otagonist, Gabriel and Mary, kneels within a shrine which has been that at an angle to suggest that it faces the other; for this reason we see ly the exteriors and a small part of the interiors of the two structures. Of all the buildings in the Paduan frescoes, these shrines are ost reminiscent of the architectural settings at Assisi, because of the urtains, and the complicated consoles supporting the balconies. The If-possessed figures of Gabriel and Mary, especially the latter, have sen given an extraordinary solidity. The foreshortening of Mary's ms has been carried out with a precision that anticipates the techcal accomplishments of the fifteenth century.

The illusion of depth in these scenes is heightened by another of iotto's innovations which appears throughout the chapel. Although this time he had mastered the technique of representing figures in ofile, he was left with the problem of how to represent their haloes, ace the halo of a figure seen frontally appears as a solid disk tached behind the head, whereas that of a figure in profile should, gically, appear foreshortened. He attempted to solve the problem making the haloes of figures in profile oval, like those of Gabriel d Mary in this scene. Later he was to abandon this solution.

The narrative continues with the scene of the *Visitation*, which opears in the panel directly below the Virgin of the *Annunciation*, the right-hand side of the chancel arch. Here the figures are more inspicuous since they are painted to the same scale as those of the

cenes from the life of Joachim. adua, Arena Chapel. 6. Joachim among the Shepherds. other frescoes, though the area itself is quite small. The five scenes on the right wall represent the *Nativity*, the *Adoration of the Magi*, the *Presentation in the Temple*, the *Flight into Egypt*, and the *Massacre of the Innocents*. The well-constructed shed in the first scene reappears in the second, set at a slightly different angle. The temple in the third scene is the same as that which appears in the *Expulsion of Joachim from the Temple* and the *Presentation of the Virgin in the Temple*, but this time we are shown only the shrine over the altar.

The Flight into Egypt, one of the most famous of the Arena Chapel frescoes, is set in a rocky landscape like that in the Stigmatization of St Francis at Assisi, though it is softer in appearance. Mary and her child form an isolated group in the centre of the scene, their solemnity enhanced by the rich, beautifully rendered folds of her cloak. Her profile is much more convincing than any of those in the frescoes at Assisi, a sign that once the artist had freed himself from the medieval prejudice against the profile he lost no time in mastering it. We can only imagine the startling effect this Virgin in full profile must have had on Giotto's contemporaries, accustomed as they were to the pictorial conventions still respected by other painters.

The Massacre of the Innocents is the only scene in the chapel in which two buildings appear. The octagonal structure on the right recalls a baptistery (an allusion to the baptism of blood of these unfortunate infants?), and is depicted with even greater clarity than the structures at Assisi. One feels that it is a real building, an effect that is heightened by the subtle distinction made between the walls of the radial chapels and the buttresses that divide them; by the green marble mouldings; by the sky visible through the mullioned windows, which suggests that the alternation of buttress and chapel continues beyond our view; and by the interplay of light and shade. Giotto's handling of the shadows in this scene (note the shadow under the roof of Herod's balcony) is even more skilful than in his Assisi frescoes, and provides yet another demonstration of the realism of his art. There are no sacred figures in this scene, and the

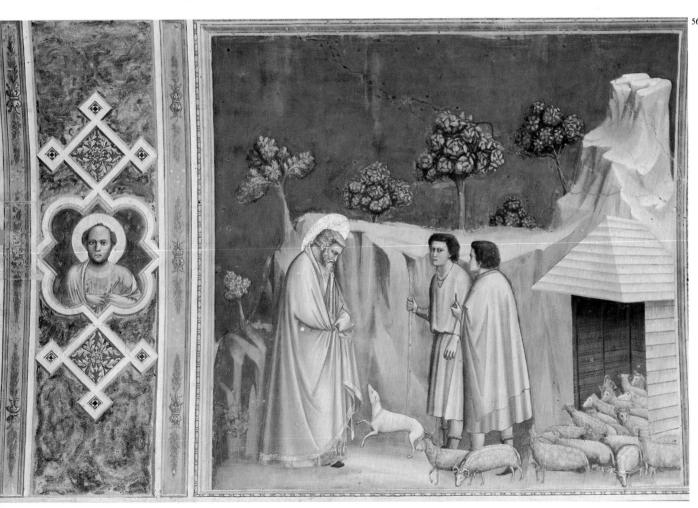

centre of the composition has been reserved for the figure of an executioner who draws his sword against a child still clinging to its mother's breast. His attitude is echoed in the figure behind him, herculean and ominous under his hood.

The six scenes on the opposite wall — Christ among the Doctors, the Baptism of Christ, the Marriage at Cana, the Raising of Lazarus, the Entry into Jerusalem, and the Expulsion of the Money-changers from the Temple — have the most solemn narrative tone of all the frescoes, perhaps because they deal with Christ's adult mission.

Christ among the Doctors is the most poorly preserved of all the frescoes in the chapel, but we can still perceive its splendid architectural setting. It was the first of the Paduan frescoes to be set wholly within an interior, and was laid out according to a scheme which recalls Assisi scenes such as the Confirmation of the Rule and St Francis Preaching before Honorius III. It is even more reminiscent of the Apparition to Gregory IX, which has the same, slightly off-centre viewpoint which was determined in both cases by the position of the fresco, the Assisi scene being at the end of its bay, and the Paduan scene next to the entrance, at the far end of the left wall of the chapel.

The very high quality of parts of the Baptism of Christ becomes evident if we consider the awe-inspiring face of Christ, the skilful foreshortening of God the Father, and the masterly execution of the heads of John the Baptist and the two disciples behind him. However, the water in which Christ stands is painted completely irrationally since if it rises to his navel it should cover part of the rocks and at least the feet of the other figures. This strange river has its origins in a deeply rooted iconographical convention which could be considered emblematic of the medieval artist's inability to 'see' the reality of this world (or, if we prefer, of his desire to abstract that reality). We do not know if this inconsistency is a result of an oversight on the part of the artist, if it was imposed on him by his patron, or if it represents a surrender to iconographic tradition in order to avoid showing Christ completely nude. At all events, it demonstrates that Giotto was still capable of being influenced by the conventions of medieval painting.

The dramatic tension of the two preceding scenes is temporarily relieved in the *Marriage at Cana*, where the homeliness of the interior is emphasized by the striped wall-hanging, the round-bellied amphorae, and the comic characterization of the guests and servants. The tone becomes solemn again in the three scenes that follow, but even here Giotto never misses an opportunity for heightening the realism of such things as the wooden cages and stalls in the *Expulsion of the Money-changers from the Temple*. The cage held by one of the money-changers was an afterthought, added when the plaster was almost dry, and for this reason barely visible today. We now come to the scene on the left side of the chancel arch, *Judas receiving Payment for his Betrayal*. Judas is shown in profile, with a black halo and with the devil standing behind him. His portrayal is in keeping with those simple didactic precepts that would have evil revealed by an ugly

The story continues on the tier below, on the window-side of the chapel. Here we have a symmetrical arrangement (an outdoor scene flanked by two indoor scenes) of scenes from the Passion of Christ — the Last Supper, the Washing of Feet, the Kiss of Judas, Christ before Caiaphas, and the Flagellation. The quiet solemnity of the first two scenes, which have been given the same setting, is followed by the frenzied activity in the Kiss of Judas, where the scene is dominated by the massive figure of Judas, one of the most impressive of Giotto's creations, and the sweep of his cloak as he reaches out to embrace Christ. The proximity of the beautiful profile of Christ and the repellent profile of Judas becomes a confrontation of absolute good and absolute evil. The scene of Christ before Caiaphas provides yet another demonstration of the artist's increasing independence from the pictorial conventions of his day. This is a night scene in which a torch, now darkened because of alterations in the pigment, illuminates the wooden ceiling from beneath, an effect of unprecedented subtlety in a period when most artists continued to adhere to the anti-naturalistic canons of medieval painting.

In the corresponding tier on the opposite wall are the Road to Calvary, the Crucifixion, the Lamentation, the Resurrection

represented by the *Noli me tangere* scene (instead of the three Marat the tomb), the *Ascension*, and the *Pentecost*. Apart from the *Roc to Calvary*, these scenes all appear on the upper walls of the Upp Church at Assisi.

The *Road to Calvary*, which, like the scene above it, *Chri among the Doctors*, is in very poor condition, shows the procession a Calvary leaving from the same city gate which Christ enters a triumph in the *Entry into Jerusalem*. Although the scene has certal affinities with some famous fourteenth-century representations the same subject, like Simone Martini's panel picture in the Louv (the similarity is especially close in Christ's backward glance at h mother), the tone is much less emotive.

Some of the most dramatic parts in the *Crucifixion* and the *Lamentation* are played by the small angelic spirits, who appears have the lower part of their bodies hidden by clouds, a much more effective solution than that devised for the angelic spirits at Assis whose bodies are merely truncated. These small beings communicate their almost savage desperation through an extraordinary variety cattitudes and facial expressions not given to their human counterparts.

The Arena Chapel.

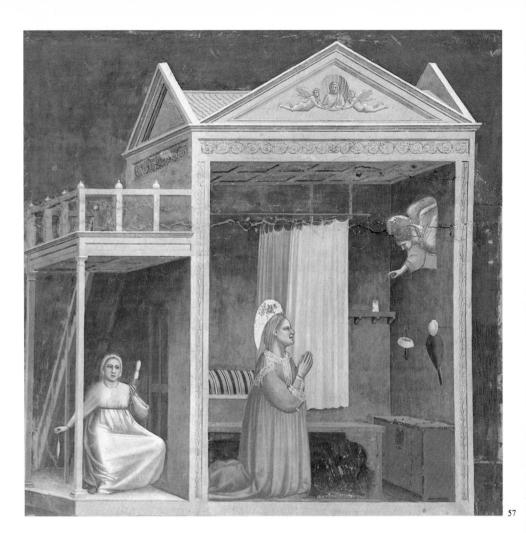

cenes from the life of Joachim.
Padua, Arena Chapel.
7. Annunciation to St Anne.
8. Joachim's Sacrificial Offering.

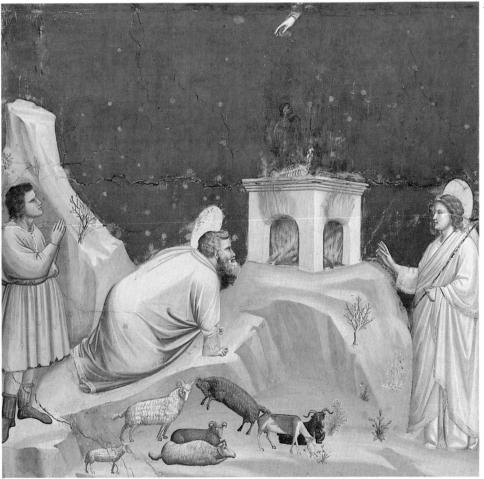

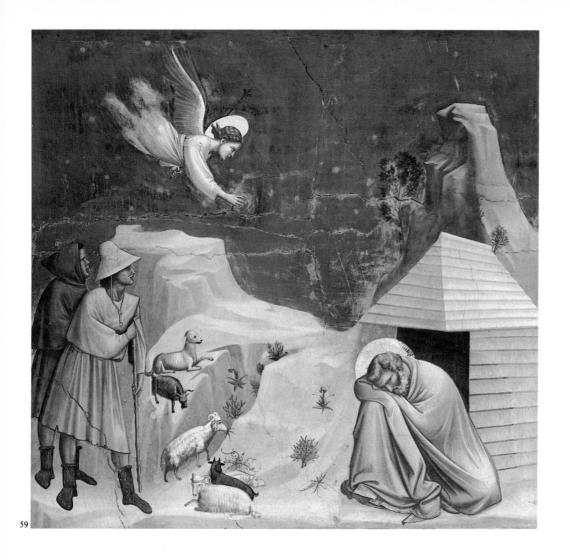

Scenes from the life of Joachim. Padua, Arena Chapel. 59. Joachim's Dream. 60. The Meeting at the Golden Gate. 61. Birth of the Virgin.

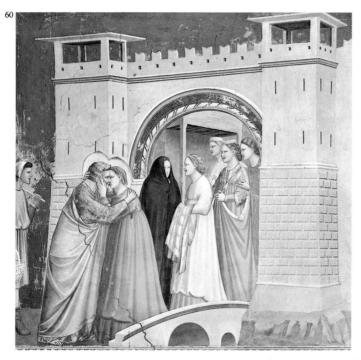

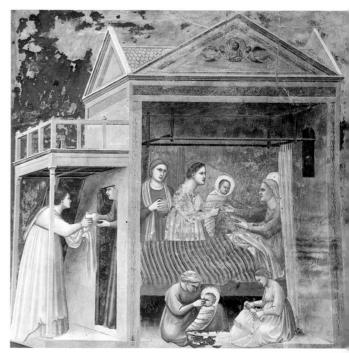

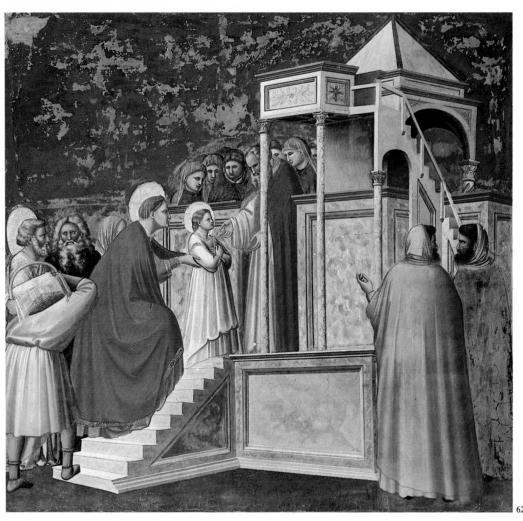

Scenes from the life of the Virgin.
Padua, Arena Chapel.
62. Presentation of the Virgin in the Temple.
63. The Rods brought to the Temple.
64. Prayer of the Suitors.

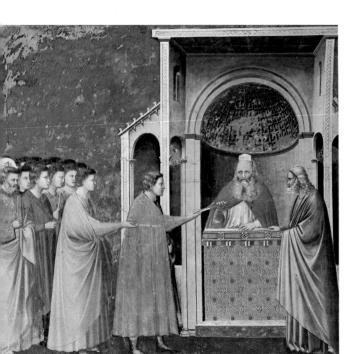

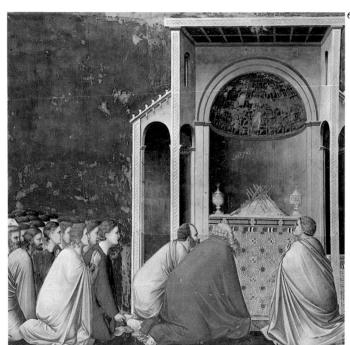

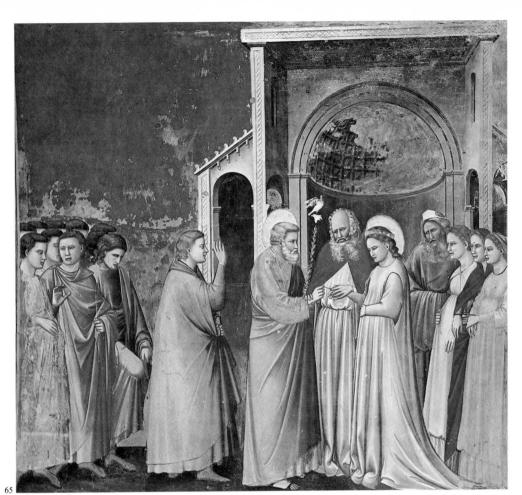

Scenes from the life of the Virgin. Padua, Arena Chapel.
65. Marriage of the Virgin.
66. Wedding Procession.
67. Wedding Procession (deatil).

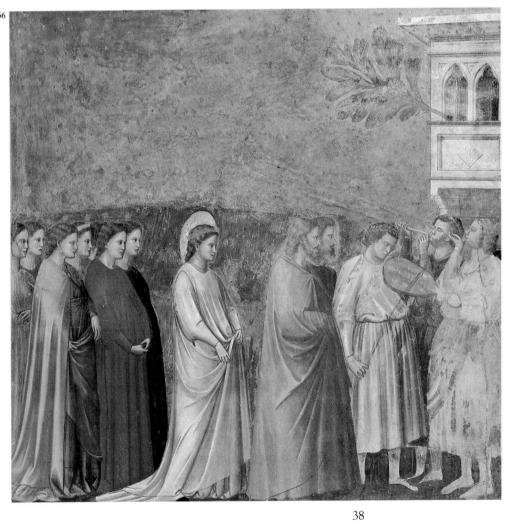

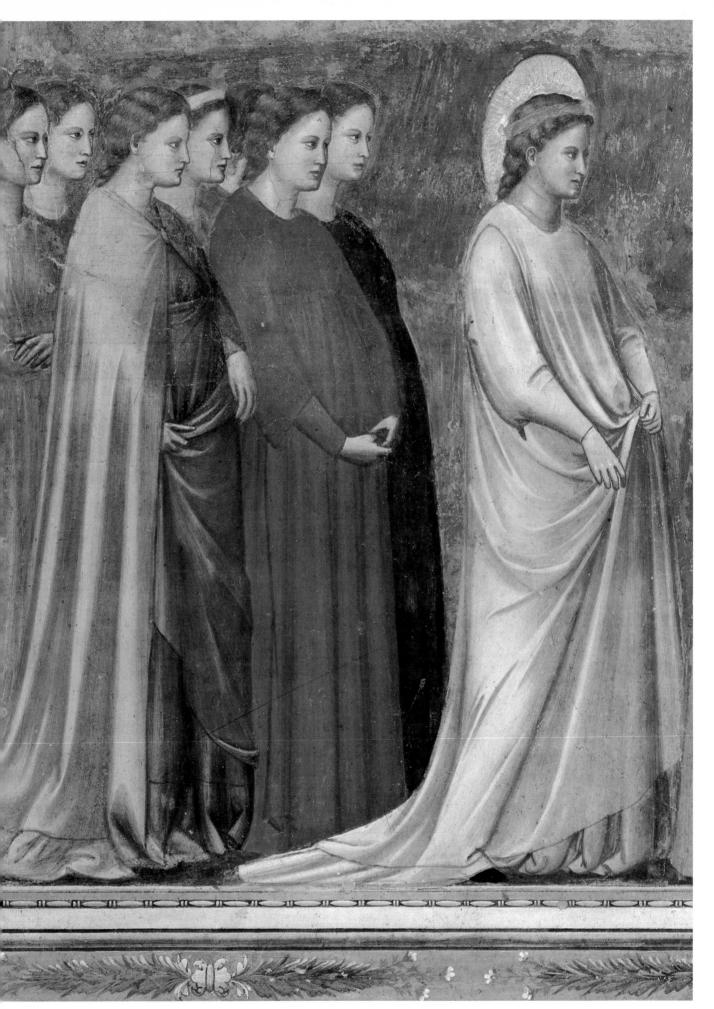

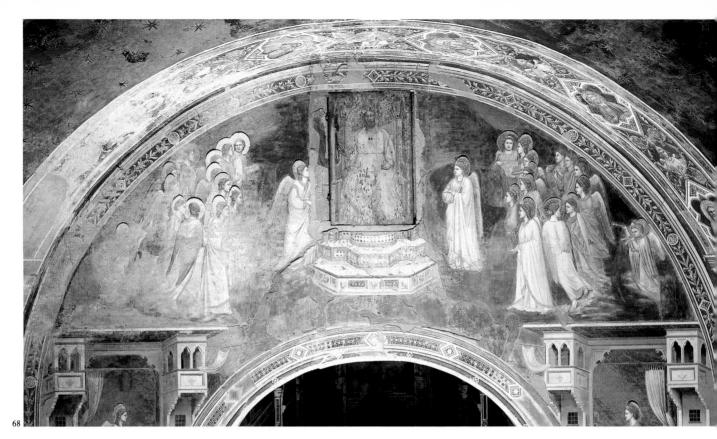

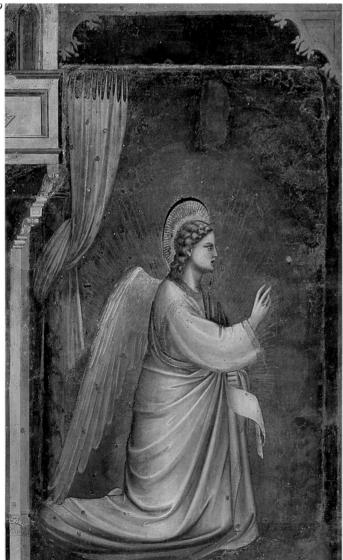

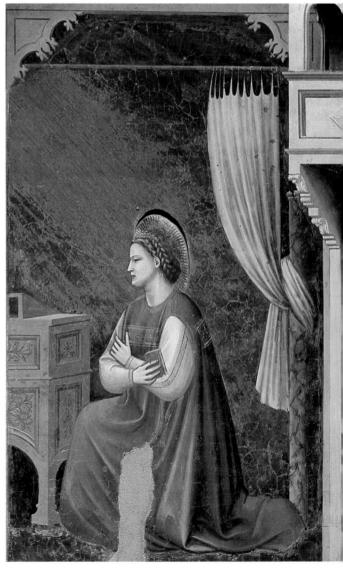

enes from the life of the Virgin.
dua, Arena Chapel.
Annunciation.
Archangel Gabriel.
Virgin Mary.
I. Visitation (with the trompe wil painted chapel below).

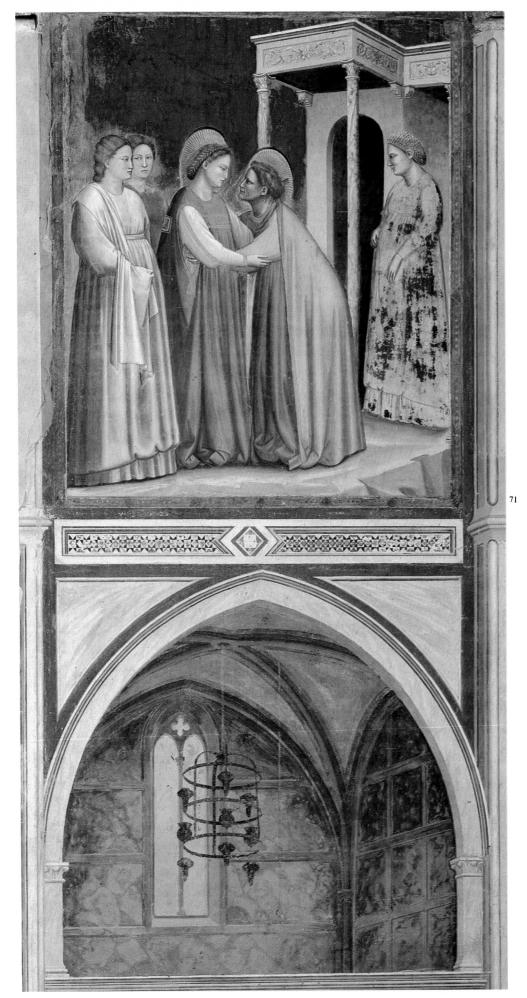

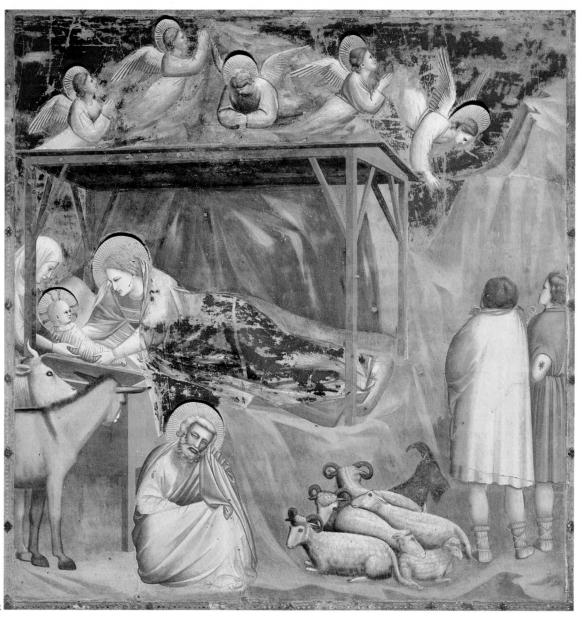

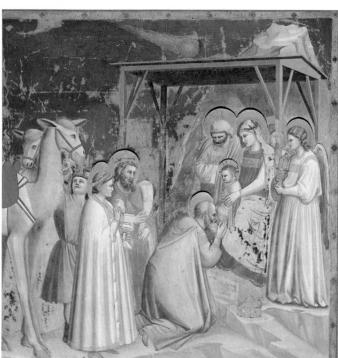

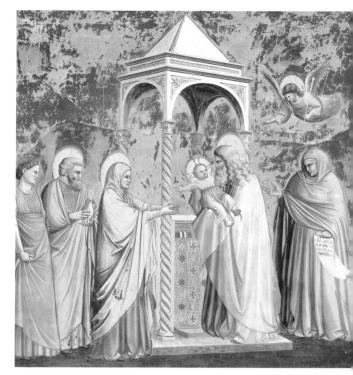

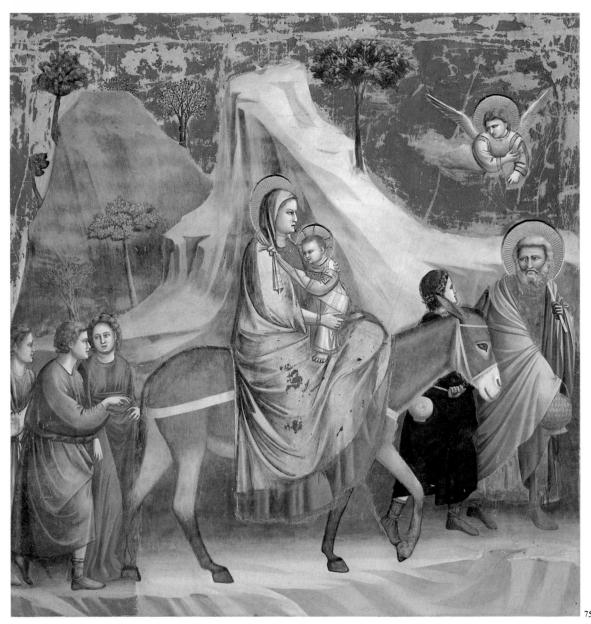

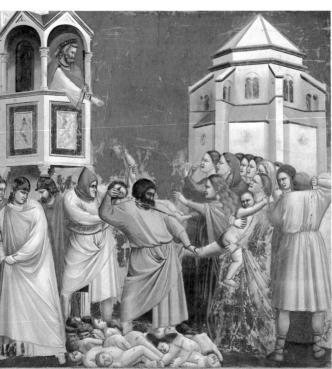

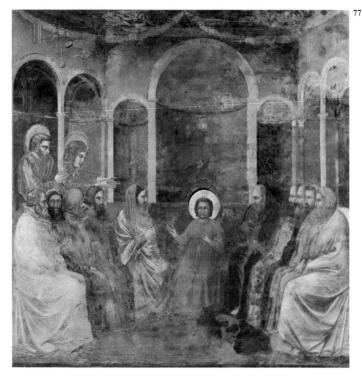

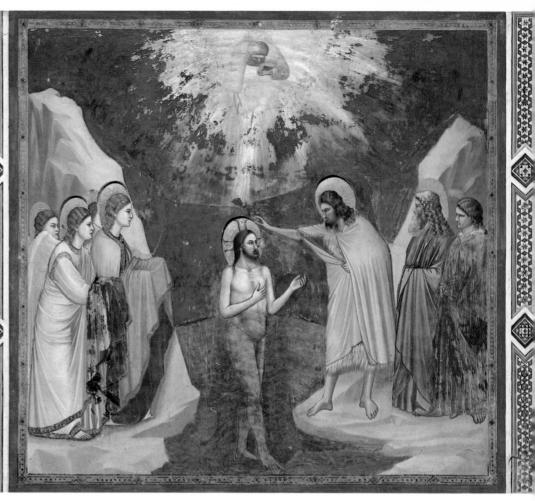

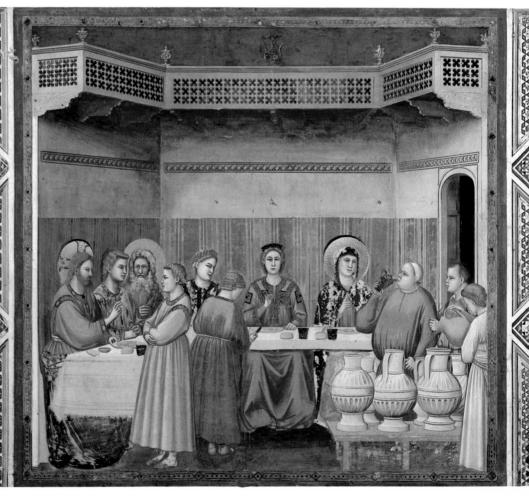

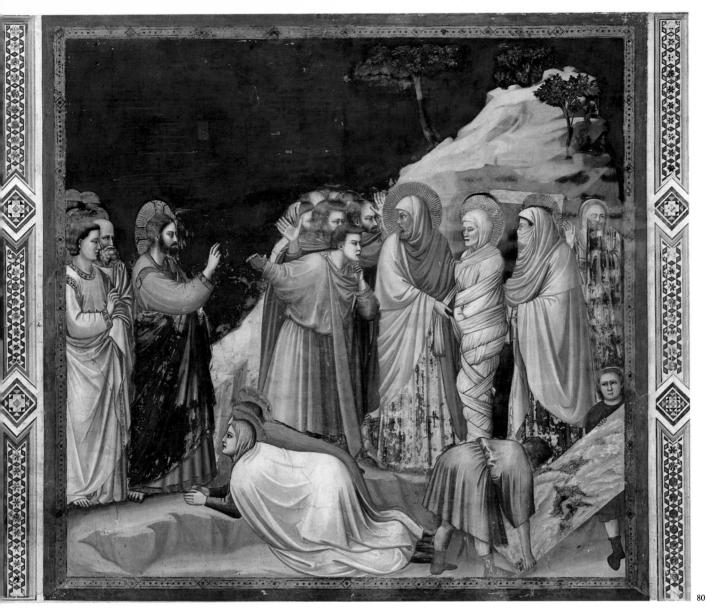

ages 42-43)

enes from the life of Christ. adua, Arena Chapel.

2. Nativity.

3. Adoration of the Magi.

4. Presentation in the Temple.

5. Flight into Egypt.

ourteenth-century art.

5. Massacre of the Innocents.

7. Christ among the Doctors.

Scenes from the life of Christ. Padua, Arena Chapel.

78. Baptism of Christ.

79. Marriage at Cana.

80. Raising of Lazarus.

The main figures in the Lamentation express their grief with a straint of gesture reminiscent of the art of antiquity, as can be seen, or instance, in the figure of St John, who bends over with his arms utspread, or the saint on the far right, who stands with his arms at is sides, his hands clasped — a gesture which appears in the same tene at Assisi. In this fresco Giotto has abandoned the frenetic novement typical of Byzantine scenes of the Deposition to return to n older, fuller, more solemn expressiveness reminiscent of Greek ragedy. Like an arrow, the rocky ridge in the background descends indicate the emotional fulcrum of the composition: the juxtaposed eads of Mary and Christ. The figures in this scene have been given a orporeality that makes them among the most impressive of

The dramatic tension of the Lamentation is relieved in the more

tranquil scene that follows it. In conformity with the Bible, Christ's Resurrection is represented indirectly, through events that bore witness to it — in this case the empty tomb with the two angels and the *Noli me tangere*. The sleeping soldiers provided Giotto with the opportunity for doing some virtuoso foreshortening, as in the *Resurrection* at Assisi.

The Ascension and the Pentecost are not among the most famous of the Arena Chapel frescoes, despite their very high quality, and the decorative and colouristic richness which underline their spiritual significance. The strikingly decorated mantle worn by one of the apostles is as magnificent as the gold-trimmed garments of the souls freed from limbo, who ascend heavenward with Christ. It is worth noting that the setting of the Pentecost is very nearly the only one at Padua that directly reflects contemporary Gothic architecture.

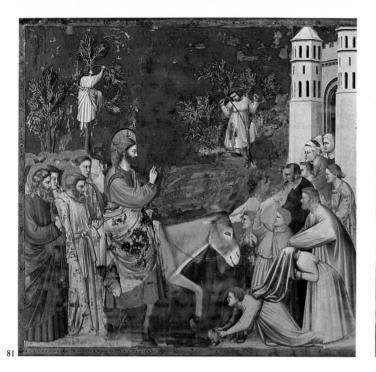

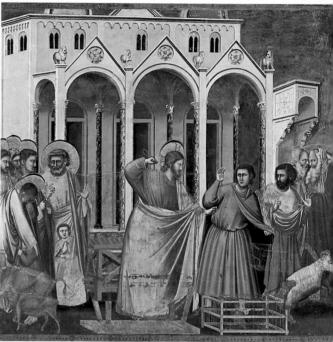

Scenes from the life of Christ. Padua, Arena Chapel.

81. Entry into Jerusalem. 82. Expulsion of the

Money-changers from the Temple. 83. Judas receiving Payment for his Betrayal.
84. Last Supper.
85. Washing of Feet.
86. Kiss of Judas.

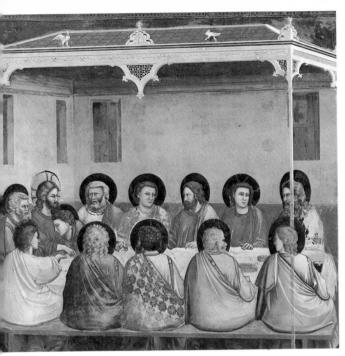

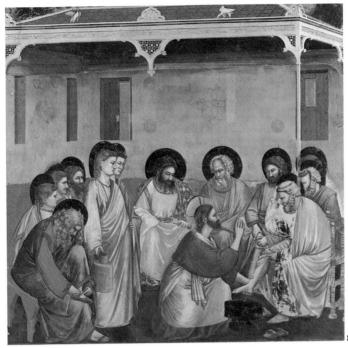

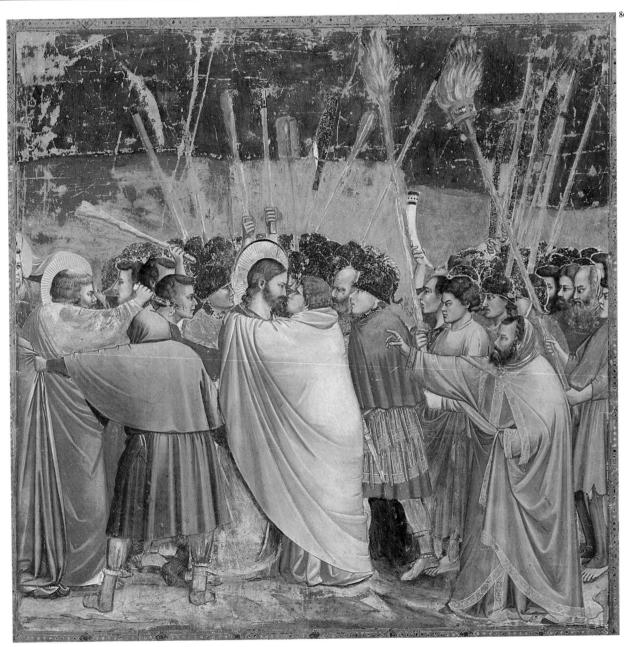

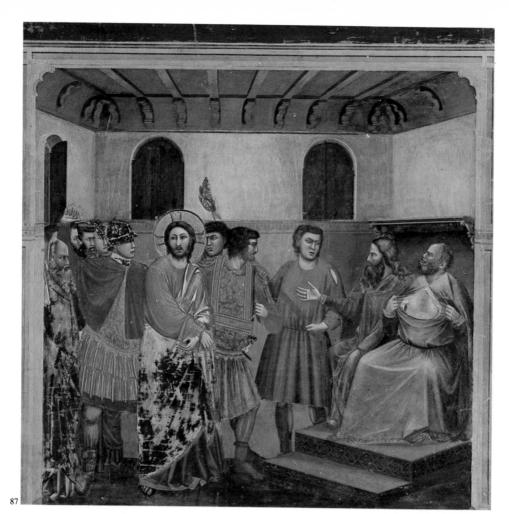

Scenes from the life of Christ. Padua, Arena Chapel. 87. Christ before Caiaphas. 88. The Flagellation.

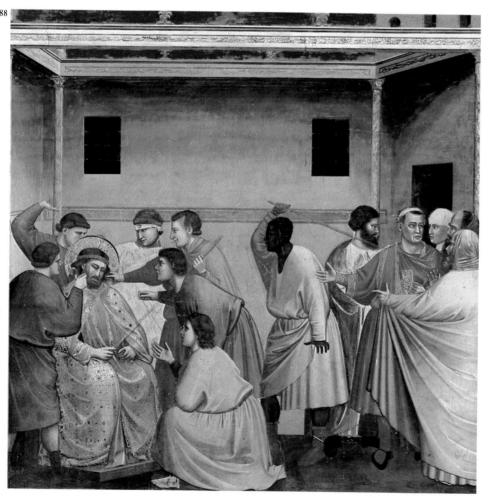

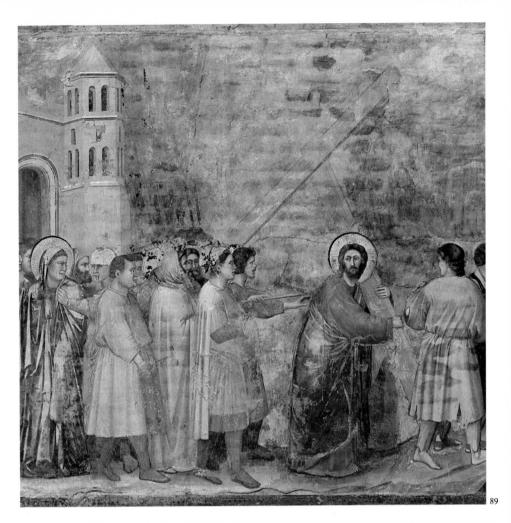

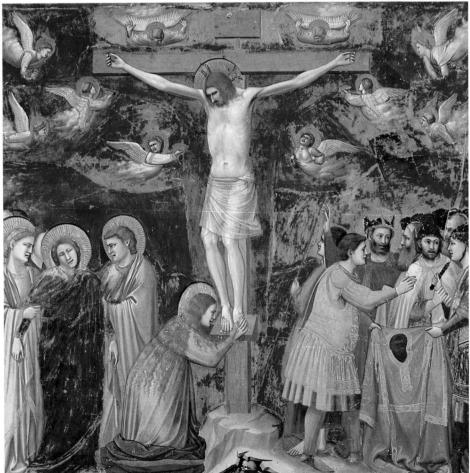

Scenes from the life of Christ. Padua, Arena Chapel. 89. Road to Calvary. 90. Crucifixion.

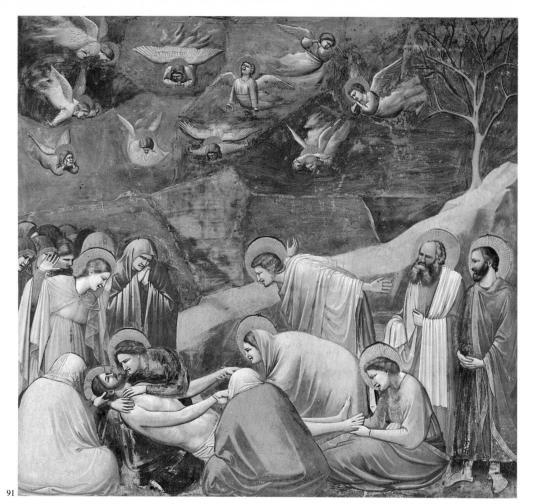

Scenes from the life of Christ. Padua, Arena Chapel.
91. Lamentation.
92. Noli me Tangere.
93. Ascension.
94. Pentecost.

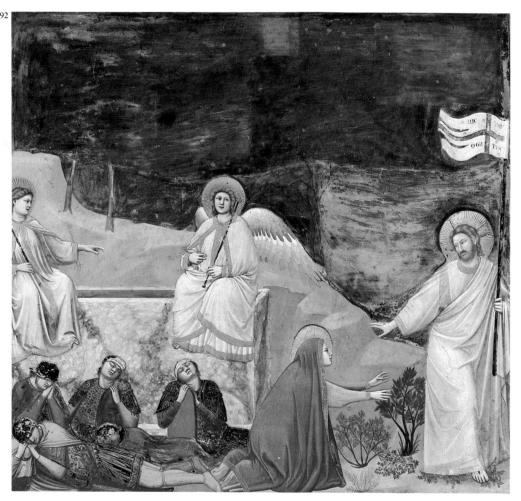

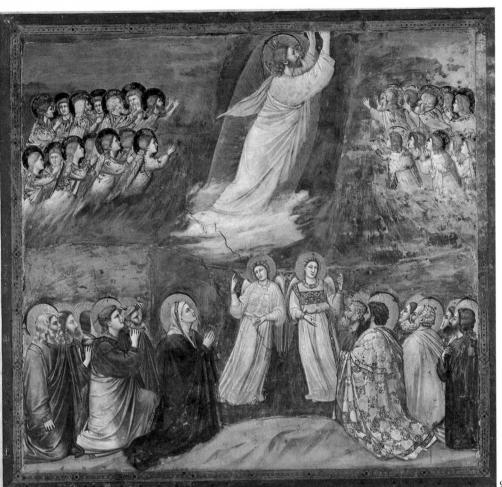

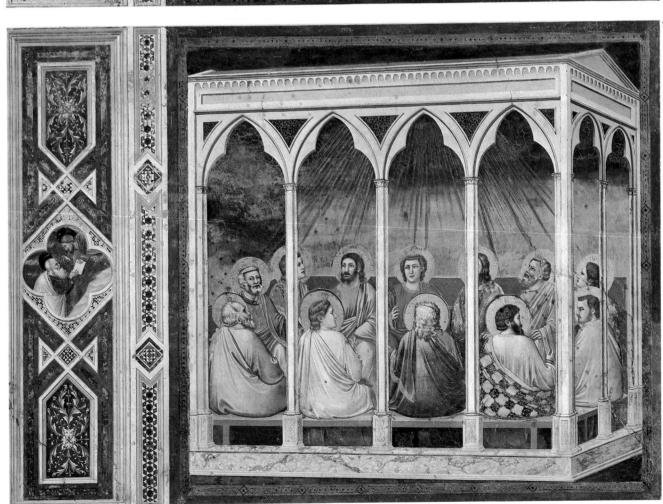

The inclusion of the Seven Virtues and Seven Vices in the chapel decoration was in accordance with the didactic programme of many thirteenth and fourteenth-century decorative schemes. I have already referred to the novelty of the feigned marble dado, a device in keeping with Giotto's conception of architectural illusionism, where these images are inserted as if they were sculptural reliefs. I have also touched upon the prosaic aspect of these works in comparison with the lofty narrative tone of the scenes of the life of Christ. This prosaic aspect has often been considered a defect, which has in turn led to a certain degree of scepticism as to Giotto's authorship. This is probably the result of a commonplace notion that poetry is superior to prose, the tragic to the comic, the sublime to the normal, the solemn to the everyday. Furthermore, there is a mistaken idea that an artist bound to the representation of a set theme is necessarily limited in his freedom of expression, and his inspiration and the quality of his work are therefore impaired — as if a prescribed theme had prevented Ambrogio Lorenzetti from painting some of the most original frescoes of the whole of the fourteenth century, the Good and Bad Government cycle in the Sala della Pace in the Town Hall of Siena. These works were anticipated in the Arena Chapel, in the fictive bas-relief on Justice's throne, where the horsemen on the sides and especially the dancers in the centre anticipate features of Lorenzetti's frescoes

The figures of *Justice and Injustice* are larger than those of the other Virtues and Vices, and occupy a central position on the dado. Both are represented as rulers — Justice wears a royal crown, and Injustice appears as a tyrant; their role as symbols of good and bad government respectively is indicated in the small reliefs on their thrones.

The other allegories are perhaps of lesser importance, in spite of the complexity of their symbolism, which is not immediately comprehensible. However, many of these figures have been represented with extraordinary subtlety and delicacy; for instance, *Prudence's* second face is represented by the profile of a bearded man at the back of her head.

Each of these figures should be considered first and foremost as an allegory, this being the reason for its inclusion in the decorative scheme. Prudence, who also symbolized the virtue of intelligence, is shown as a mature lady seated at a desk, as if she were a schoolmistress, while her opposite, Foolishness, appears as a dimwitted youth dressed as a buffoon. The Herculean Fortitude (she wears a lionskin, the attribute of Hercules) is armed with mace and shield, and stands with her feet set firmly on the ground. Her opposite, Inconstancy, struggles to maintain her balance as she sits on an unsteady wheel on a sloping floor. Temperance is serene and tranquil, while Wrath tears the dress from her breast, repeating Caiaphas' gesture of rage before Christ. Justice is shown as the personification of prosperity, while the tyrant Injustice occupies a crumbling turreted throne. Faith, hieratic in pose, is contrasted to the figure of Infidelity (idolatry), who is led on a rope by his female idol, his helmet making him impervious to the word of God from above. The smiling figure of *Charity*, who is also a symbol of generosity, fecundity and happiness, has her opposite in the grotesque figure of Envy. The youthful Hope flies upward to receive the crown that awaits her, while Desperation has hanged herself (note how the pole bends slightly with the weight of her

The decorative bands on the walls above contain several scenes from the Old Testament and busts of saints and prophets. The Old Testament scenes are of a very modest standard, and owe their presence in the chapel to the Gothic tradition of representing parallels between the Old and New Testament. Some of the figures of saints and prophets are of very high workmanship, and among the most impressive of Giotto's repertoire.

The entrance wall is filled by the imposing Last Judgement. This scene is as complex and crowded as the frescoes on the side walls are concentrated and reduced to essentials, and does not give the impression of order and balance of the others. Indeed, the composition of the various parts of the mystical vision of Judgement Day doubtless presented a serious problem to an artist whose style depended on clarity both of subject and form. The figure of Christ

the Judge is enclosed within a mandorla, surrounded by angels which seems to be independent of its surroundings. It occupies the centre of a concave recession created by the curve of the ledge supporting the thrones of the twelve apostles (a conception which calls to mind certain late fifteenth and early sixteenth century worklike Raphael's *Dispute over the Holy Sacrament* in the Stanza della Segnatura in the Vatican). The space is made even deeper by the downward slope of the rows of angels above, who look like a heavenly battalion drawn up on parade.

Also noteworthy are the figures of the two angels in the uppermost part of the fresco who roll out the sky as if it were a scoll, revealing the gem-studded walls of the heavenly Jerusalem, the two angels holding the cross below the mandorla, and the river of fire that flows from the mandorla down into hell. The rigid scheme of painting figures on different scales graded according to their importance does not contribute to a harmonious relationship of parts in a work such as this; from the enormous figure of Christ to the Lilliputian figures of the redeemed and the damned there is a continuous gradation of size which confounds the artist's attempt to instil order into the huge composition.

Yet if we compare this Last Judgement with earlier works like the Last Judgement in Sant'Angelo in Formis, that in Santa Maria Assunta on the island of Torcello, or the one in the cupola of the Baptistery in Florence, all of which are divided into a series of independent, horizontal compartments, we can see just how much unity Giotto introduced into this work by eliminating the traditional subdivisions, and putting all the groups into the same pictorial space. The fact that iconographic tradition still exerted considerable influence is evident in the differentiation of the various groups, but even here Giotto's desire for unity led him to innovate, to make the mandorla of Christ a kind of centripetal force towards which the various groups gravitate.

Virtues and Vices. Padua, Arena Chapel.

95. Prudence.

96. Fortitude.

97. Temperance.

98. Justice.

99. Faith

100. Charity.

101. Hope.

102. Desperation.

103. Envy.

104. Infidelity (Idolatry).

105. Injustice.

106. Wrath.

107. Inconstancy.

108. Foolishness.

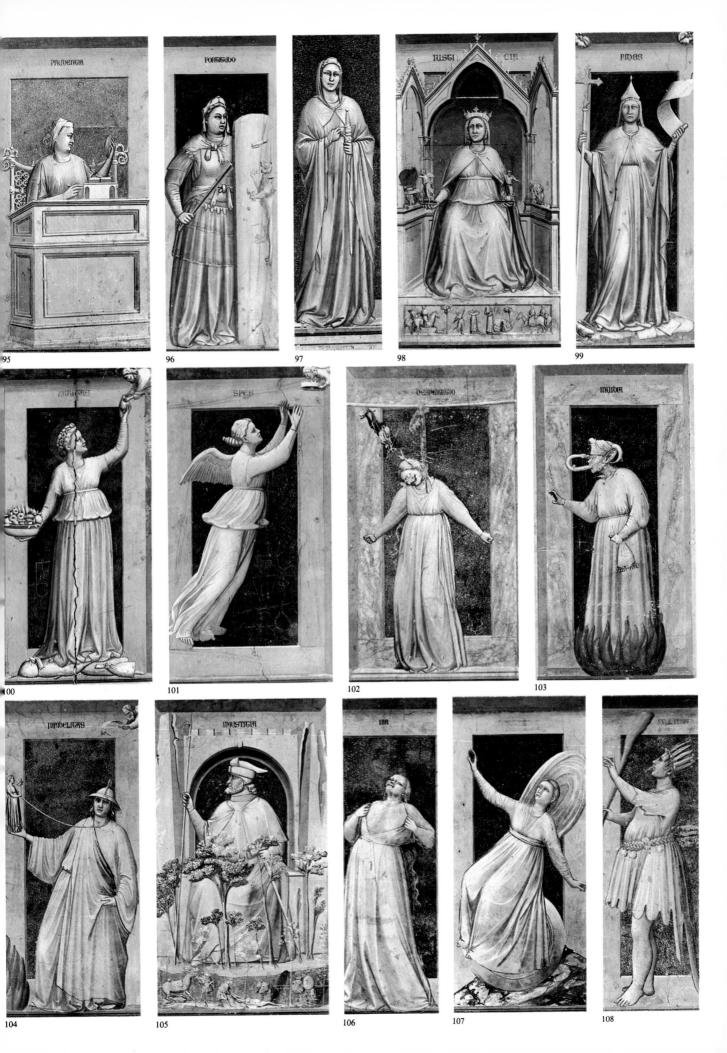

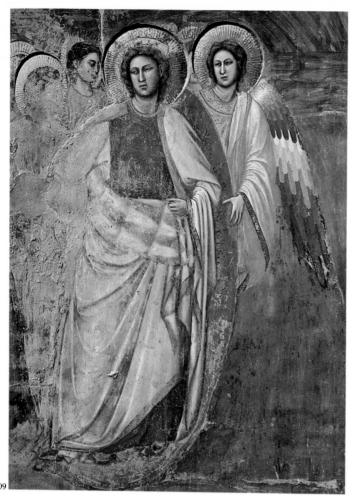

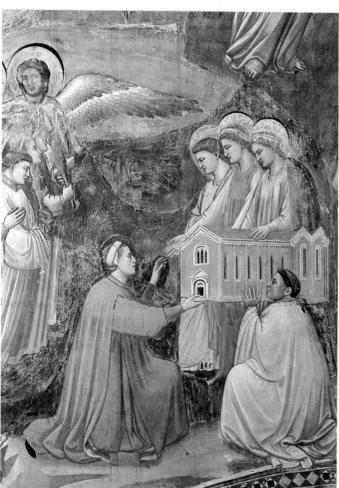

Christ sits within his rainbow-hued mandorla, majestic and commanding, both in pose and scale (though compared to earlier representations he appears humane). With his left hand he rejects the damned while, still frowning, he turns his face towards the elect, offering them his right hand. The apostles sit solemnly on their thrones, the richest of which is occupied by Peter. The youthful Virgin, brown-haired and sweet-faced, seems to offer her hand to the first figure in the top row of the elect, probably St. John the Baptist, as if to lead him towards Christ. Unfortunately, this part of the fresco is in very poor condition, and we can barely make out a procession of elders and important figures characterized in the same way as Joachim, the old Simeon, St. Joseph and the elder apostles.

The group of elect immediately below is in a better state of preservation. The figures have not been given haloes, even though they number among them important saints such as Francis and Dominic, and those, like Catherine, who had inspired a vast number of legends. Men and women, laymen and ecclesiastics move in procession towards Christ, accompanied by a row of smiling angels. Their arrangement in parallel lines receding into space gives rise to those curious rows of heads in profile with which Giotto indicates an orderly crowd in space. The same device was used in the group of kneeling friars in the *Confirmation of the Rule* at Assisi and in the

group of apostles in the Ascension at Padua.

The damned, who are shown in the lower right hand corner, fall

into a hell dominated by the figure of Satan. This hell teems with hopeless diminutive figures being subjected to a variety of comically indecent humiliations and torments by apish devils. It is a far cry from Dante's tragic vision of hell and recalls only a few verses of the *Inferno* about the area of hell known as the Malebolge. Almost all these figures can be attributed to Giotto's assistants, though here, too, the guiding hand of the master can be perceived in the rich play of imagination which characterizes the whole, and in the execution of certain parts, which suggest his direct intervention. This is true of the wonderfully immediate episode that takes place on the brink of hell, below the cross, where two devils conduct a struggling man back to the damned, tugging him by his clothes, which are being pulled over his head to reveal his disproportionate genitals.

Below the cross, on the left, is the dedicatory scene, in which Enrico Scrovegni kneels before the Virgin and two saints, offering a model of the Arena Chapel upheld by an Augustinian friar. The portrait of Scrovegni, who is shown in sharp profile, is a faithful representation of the youthful features of the same man shown in old age on his marble tomb in the same chapel. His clothing and hair-style reflect the fashions of the day, and provide valuable information on contemporary costume. The figure of Scrovegni is on the same scale as the sacred figures he is addressing — it was evidently enough to show him kneeling before these figures to indicate his 'inferior' status.

The model of the chapel presented by Scrovegni differs in a few details from the real chapel, a fact which suggests that the *Last Judgement* may have been painted before the exterior of the chapel was completed. This is a strong possibility since the most pictorially advanced parts of the cycle, i.e. those most similar to Giotto's later works, appear on the wall opposite the *Last Judgement*, above and on each side of the chancel arch. The warm, rich colours of the angels surrounding God, and of the figures of Gabriel and Mary are related to the fresco decorations in the Magdalen Chapel in the Lower Church at Assisi, which are the closest to the Paduan frescoes of all of Giotto's surviving cycles.

Padua, Arena Chapel. 109. Last Judgement (detail, angels). 110. Last Judgement (detail, Enrico Scrovegni). 111. Last Judgement.

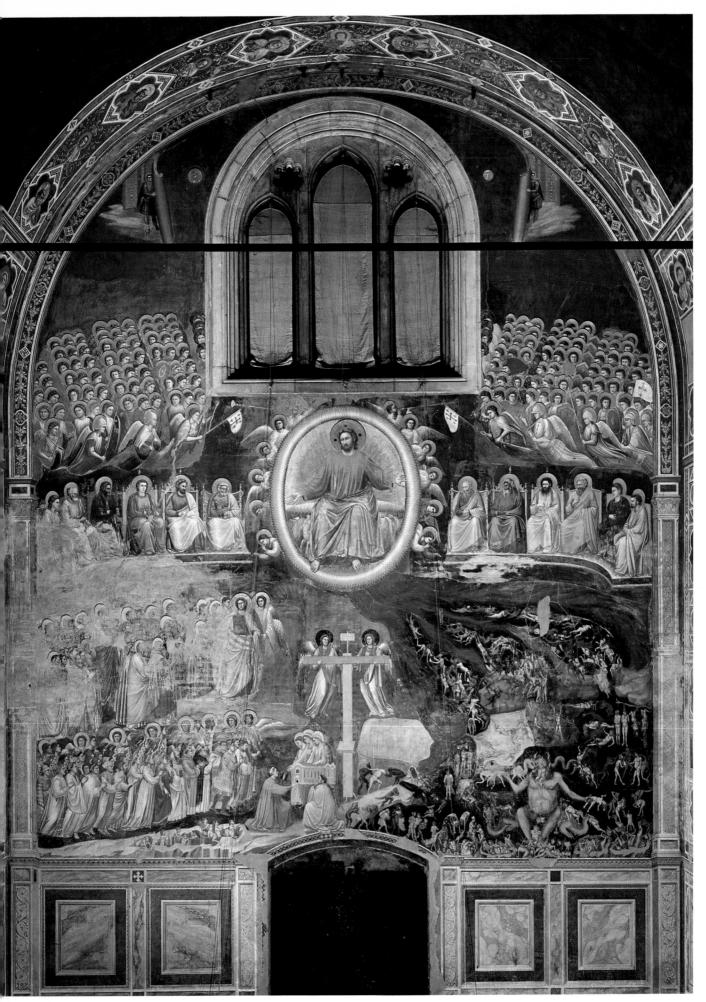

The Crucifix painted by Giotto for the Arena Chapel (now in the Museo Civico at Padua) also displays a striking similarity to the frescoed Crucifixion in the right transept of the Lower Church. But before going on to examine the Lower Church cycle, it is worthwhile lingering for a moment over two works that are closely related stylistically to the Paduan frescoes, and which may have been painted a short time before: the Ognissanti Madonna, now in the Uffizi, and the Dormition of the Virgin, now in the Staatliche Museen of Berlin.

The Ognissanti Madonna is the greatest of Giotto's panel paintings. The subject is the same as that of Duccio's Rucellai Madonna and Cimabue's Santa Trinita Madonna: the enthroned Virgin and Child among saints and angels, facing the spectator, and the Child raising his hand in a gesture of benediction. However, much had changed in the few years that separate this work from the others. The sad, remote, inscrutable Virgin of the thirteenth century has been transformed here into a very human woman who gazes serenely outward, her lips parted in a hint of a smile that reveals the white of her teeth. The earthly weight of her body is set off by the delicacy of the Gothic throne, which appears to have undergone the same process of attenuation as the Temple of Minerva in the Homag of a Simple Man at Assisi.

Compared with similar works by the great painters of the lat thirteenth century, this image of the Madonna seems to have bee greatly simplified, though by no means impoverished. The cloth of the Virgin's gown and mantle are of the finest quality. The chromati richness of the throne makes it both sumptuous and more convincing than the elaborate thrones of thirteenth century painting. The group of angels on each side of the throne occupy real space, and would seem to be the elegant retainers of a royal court.

The Berlin panel of the *Dormition of the Virgin*, which was als made for the Church of Ognissanti in Florence, would appear to b directly related to the Ognissanti Madonna. It has an unusual forma (75 cm high, 178 cm wide) and its gabled shape suggests it must hav been intended to be placed above an altarpiece. There are ver strong similarities between it and the Ognissanti Madonna; for ir stance, the angel standing behind the two smaller angels holding candles, on the right, has a profile identical to that of the ange kneeling on the right in the Ognissanti Madonna.

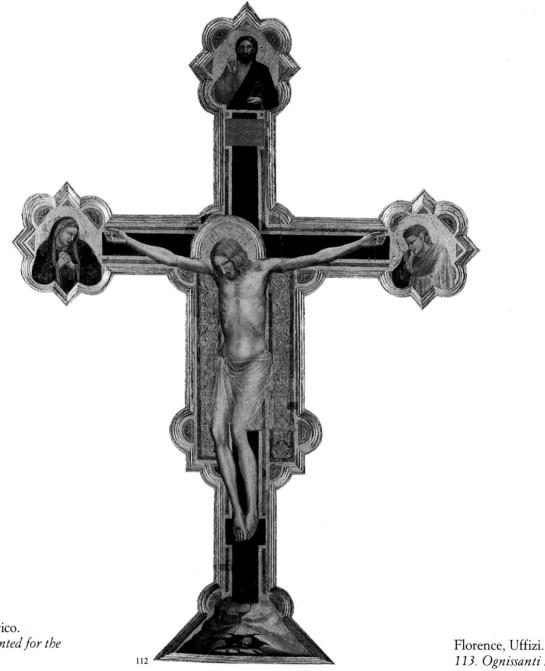

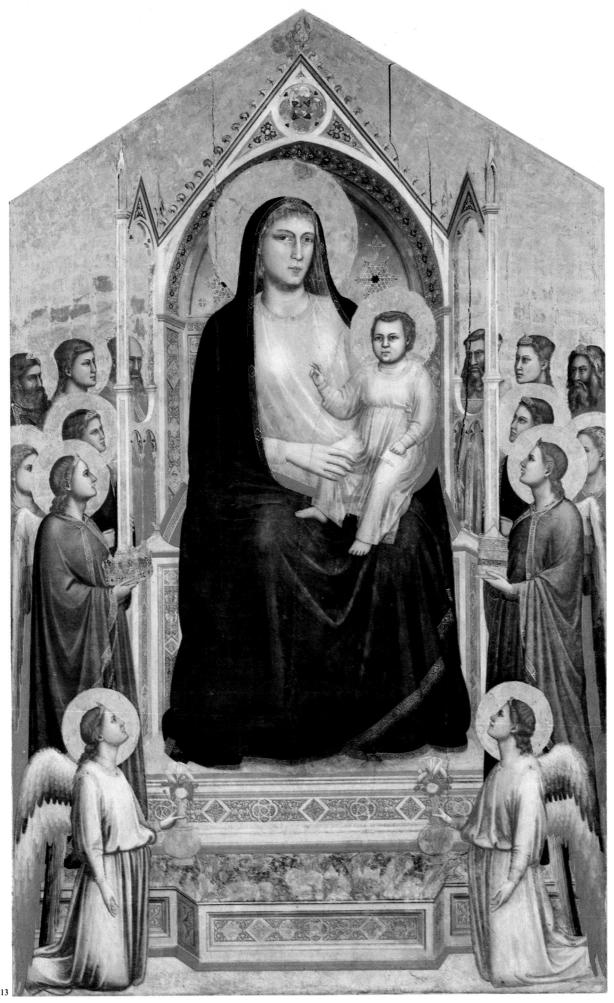

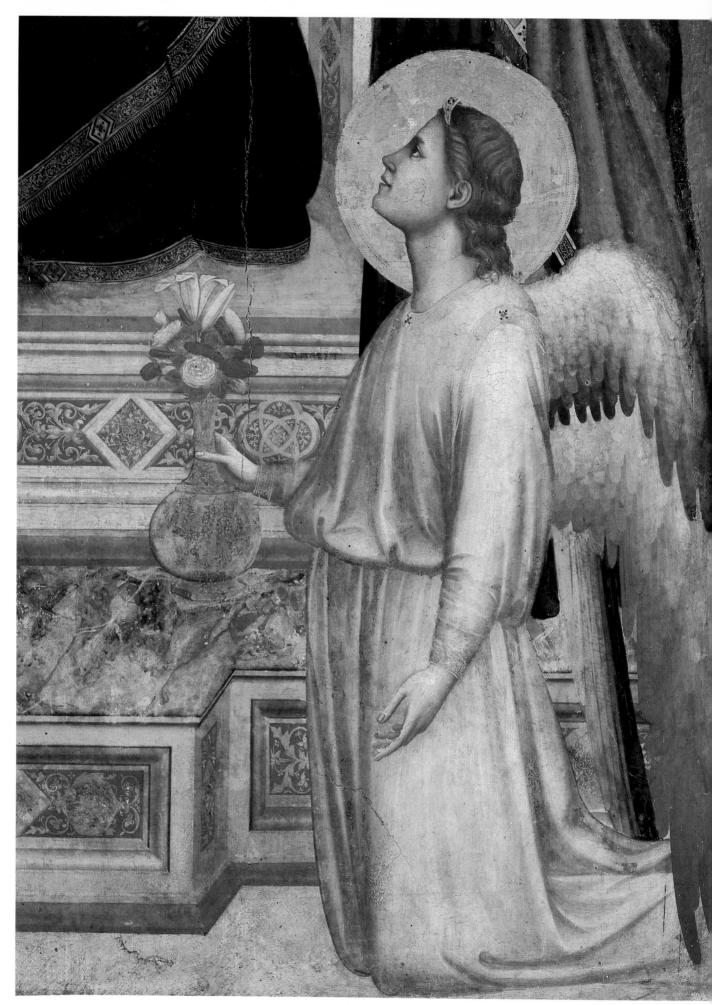

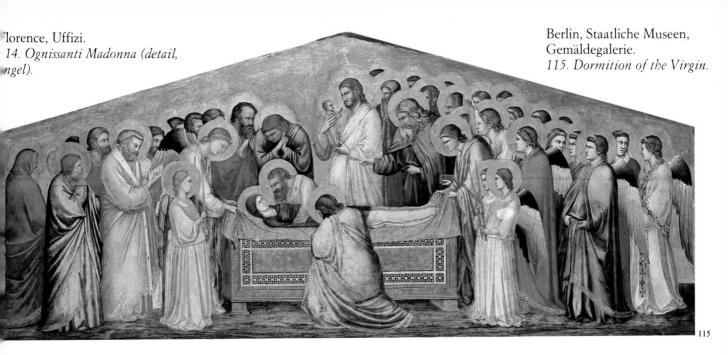

The composition is made slightly asymmetrical by the disosition of the group of angels and patriarchs on the right, who form diagonal that rises to a point above Christ's left shoulder. The group n the left forms a similar, lower diagonal which is interrupted by the gure of a young apostle (John?) who bends forward, clasping his ands. The simple sarcophagus, ornamented with Cosmatesque ecoration, is also asymmetrical, having been set at a slight angle so hat both the side and front are visible. The scene represents the

moment at which the Virgin's body is lowered into the marble tomb. Angels hold the ends of the shroud, and an apostle bends over the sarcophagus, supporting the body. Christ holds in his arms an infant in swaddling clothes, a symbol of Mary's soul. As in the Paduan frescoes, the tone is solemn, yet warm and down to earth. Certain parts such as the angel blowing into the censer and the female figure on the left, who is so covered by her drapery that only a small portion of her profile is visible, anticipate later fourteenth-century painting.

The Lower Church at Assisi

The similarity between the latest frescoes of the Arena Chapel nd the frescoes in the Magdalen Chapel of the Lower Church at Assisi has already been mentioned. The fact that Giotto's assistants vere allowed greater freedom in the execution of the Assisi frescoes loes not mean that he was not directly involved. There was more vall space at the artists' disposal in the Magdalen Chapel than at 'adua, and the two scenes that appear in both places, the Raising of azarus and the Noli me tangere are consequently larger and more mposing. The former, in particular, is much more monumental in haracter than its Paduan counterpart, despite the presence of the ame figures in more or less the same attitudes. But because the wall pace permitted greater intervals between the figures, Christ's gesure has become more dramatic, and the figures of the two Marys nore accentuated. If we observe Christ's head we see how much ofter and more mellow Giotto's painting has become. The landscape as become gentler, and by comparison the Paduan landscape ppears to have much of the hardness of the stony mountains in the legend of St. Francis.

The frescoes on the lower walls of the chapel are enclosed vithin mock architectural projections supported by lovely twisted folumns (as in the Legend of St. Francis), and those on the upper valls are surrounded by flat decorative borders (as in the Arena Chapel). In the chapel are seven scenes of the life of Mary Magdalen. The narrative begins on the middle register of the left wall, with the Supper in the House of the Pharisee (where the saint washes Christ's eet, and dries them with her hair), and the Raising of Lazarus. It continues on the same level of the right wall, with the Noli me tangere where the resurrected Christ appears to Mary in the guise of a gardener) and the Miraculous Landing at Marseilles (Mary Magdalen, azarus, Martha and others arrive safely in the French port after naving been placed on a rudderless boat by their pesecutors). In the unettes are Mary Magdalen speaking to the Angels (right wall), the

Communion and Ascent into Heaven of Mary Magdalen (left wall), and Mary Magdalen and the Hermit Zosimus (wall above the entrance to the chapel).

Minor frescoes are painted on the soffits of the windows and of the two side entrances while at the sides of the windows, arranged in two tiers, are a *Penitent saint, Mary, sister of Moses* (as is indicated by the inscription), *St. Helen*, and a *Martyred saint*. On the soffit of the entrance are twelve saints, arranged in pairs on three levels: on the left, from above, *Peter and Matthew*, a saint with a cross (Simon of Cyrene?), and a saint in armour (Longinus?), and two saints; on the right *Paul* and *David*, an elderly saint and *St. Augustine*, and two saints. On the lower section of the side walls are, on the left, *St. Rufinus, Patron Saint of Assisi, with the Bishop Teobaldo Pontano* (the latter commissioned the chapel, and is shown kneeling at the saint's feet), and the *Penitent Magdalen*; on the right, *Mary Magdalen with the Cardinal Pietro di Barro*, and the bust of a saint. On the vault, within four roundels, are *Christ giving his Blessing, Mary Magdalen, Lazarus* and *Martha*.

These frescoes were formerly thought to have been painted after 1314, before it was discovered that Teobaldo Pontano, who commissioned them, did not become Bishop of Assisi in that year, but in the late thirteenth century. We now know they were executed not long after the Paduan frescoes, probably before 1309 (a recently discovered document mentions that Giotto was at Assisi a short time before that date). The intervention of Giotto's assistants, who were given freedom here, as can be seen in the *Miraculous Landing at Marseilles*, appears to revert to a pre-Paduan, almost 'St Cecilia Master' phase of Giotto's development, while the parts where the hand of Giotto himself predominates are characterized by a pictorial and chromatic softness much more advanced than at Padua.

The human types found in the Paduan frescoes reappear here, but they are warmer in colour, the dark hair of their Paduan days has become reddish blond, and their eyes are often pale. Their

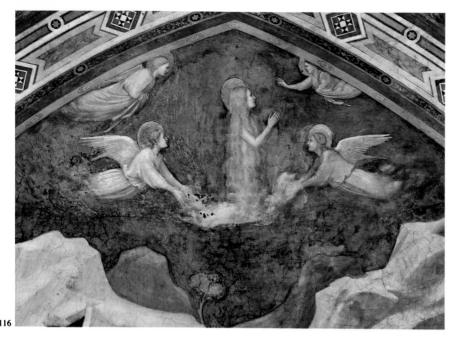

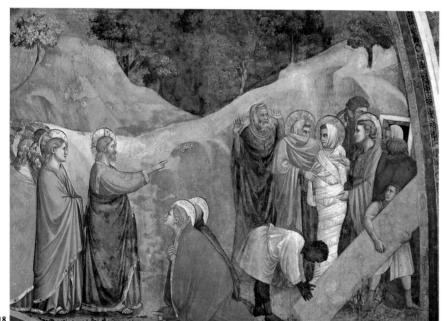

Scenes from the life of Mary Magdalen. Assisi, Lower Church. 116. Mary Magdalen speaking to the Angels. 117. Mary Magdalen and Cardinal Pietro di Barro. 118. Raising of Lazarus. 119. Noli me Tangere. 120. Noli me Tangere (detail).

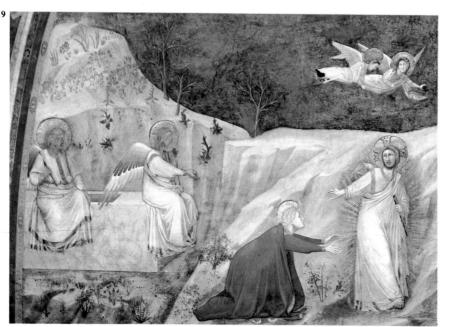

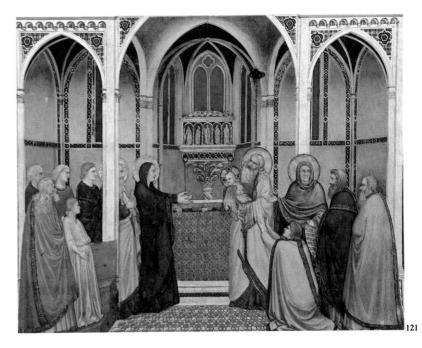

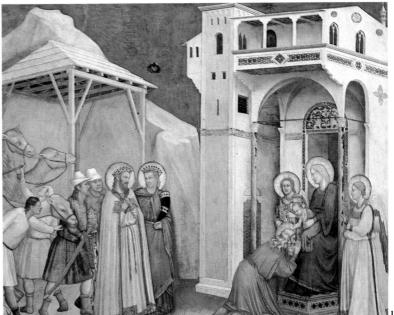

Scenes from the life of Christ. Assisi, Lower Church. 121. Presentation in the Temple. 122. St Matthew 123. Adoration of the Magi. 124. Crucifixion.

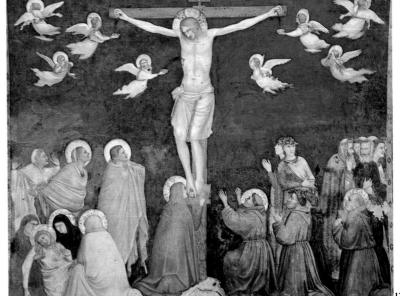

physiognomies seem more varied. The figures are on a larger scale. The colours have become warmer and creamier. The immense rock which dominates the scene in the lunette above the entrance of *Mary Magdalen and the hermit Zosimus*, is as white and soft as a cloud. The bearded profile of the hermit has been rendered with such sublety that it calls to mind the naturalistic effects that Giottino and Giusto dei Menabuoi were to achieve half a century later.

The angels who bear Mary Magdalen aloft in the scene in the lunette on the right wall have extraordinary faces, with expressions that are much softer than anything seen at Padua. The head of Lazarus in one of the vault roundels is imbued with an almost morbid pathos and sweetness. Many of the sacred figures are also more imposing and dignified than their Paduan counterparts, as can be seen in the splendid group of Christ and Mary in the Supper in the House of the Pharisee. We notice in the same fresco Giotto's scrupulous attention to the rendering of the object, evident in the minute description of the turned, high-backed chair on which Christ sits.

Some of the figures of saints on the soffit, or underside of the entrance arch are also deeply expressive. And in the magnificent dedicatory scene, Mary Magdalen, wearing a pinkish red dress sumptuously trimmed in gold, takes the hand of Pietro di Barro, who kneels before her. She stands to one side of the large, rectangular fresco, her figure set off by the blue background. The scene is enclosed within a marvellous frame painted to imitate red marble, trimmed in white, and ornamented with fictive mosaic inlays. At each side is a solid twisted column embellished with a spiralling strip of Cosmati work.

The Madgalen Chapel was the starting-point of the work carried out by Giotto and his assistants in the Lower Church, which was to include the right transept and the vault. It has been recently demonstrated that these areas were frescoed before Pietro Lorenzetti painted the scenes of the Passion in the left transept, a work executed before 1320. It is thought that as soon as the frescoes in the Magdalen Chapel were completed, Giotto and his workshop were commissioned to redecorate the right transept and the vault. This area had been previously frescoed in the late thirteenth century, as is indicated by the presence of Cimabue's large fresco of the *Madonna enthroned with angels and St. Francis*, which was spared.

In these frescoes, in which Giotto's role was probably that of planner rather than painter, there emerges the personality of one, or perhaps two of his assistants — the so-called Parente di Giotto and the Master of the Vele — who translated his ideas in their own style. The frescoes in the right transept include various miracles performed by St Francis after his death, a fresco of St Francis with a crowned skeleton, the Crucifixion, and eight events from the infancy of Christ: the Visitation, the Nativity, the Adoration of the Magi, the Presentation in the Temple, the Massacre of the Innocents, the Flight into Egypt, Christ among the Doctors, and the rare episode of the Return of the Holy Family to Nazareth. The other frescoes in the right transept were painted by other artists — Cimabue, the Master of the Cappella di San Nicola, Simone Martini and Pietro Lorenzetti.

The frescoes give an impression of splendid chromatic richness. The blues of the backgrounds are the most brilliant of the whole of the fourteenth century. The pinks, whites, yellows and greens are the softest, warmest, thickest and brightest of Giotto's palette (it is as if the walls and dark barrel vault of the transept were encrusted with precious stones). Here the artist reveals a capacity for giving concrete form to objects that at times is reminicent of the extraordinary trompe-l'oeil effects of the St Francis cycle. His skilful construction of pictorial space in frescoes such as the Presentation in the Temple and Christ among the Doctors shows the perhaps most advanced use of perspective in the fourteenth century. These frescoes became a model for Umbrian painters of panel pictures, frescoes and miniatures. Proof of their contemporary fame is provided by a few fourteenth-century drawings that have survived which reproduce details from them or whole scenes.

The standard of the frescoes, however, is lower than that of works in which Giotto's participation was more direct. In certain parts we notice a tendency to attenuate the figures, and to refine their

features in the Gothic manner. In other parts the wide-eyed figure have the somewhat pathetic look which first appears in the Lazaru on the vault of the Magdalen Chapel, and reappears in the frescoes of the vault.

However, Giotto must have supervised the painting of thes frescoes fairly closely as his hand is evident here and there, an especially in the sublime *Crucifixion*, which is perhaps the mobeautiful, refined, colourful and moving of all his Crucifixions. Whave already mentioned the evident similarity of this Christ and thone on the Crucifix made for the high altar of the Arena Chapel, similarity which provides further proof that the Lower Churc frescoes were painted not long after those in the Arena Chapel. It has been recently observed that, apart from the figures standing on the right, evidently the work of the Master of the Vele, this frescoentirely by Giotto.

None of his creations is more delicate or more moving than the crucified Christ, whose milky-white body is covered with marks of the flagellation. Only the whites of his lifeless, half-closed eyes ar visible. Kneeling at his feet, on the right, are three Franciscans whos features are so lifelike that they could almost have been painted be Masaccio, portraits even more intense and individualized than that of Enrico Scrovegni at Padua. The three solemn mourners standing of the left, St John and the two Marys, reveal their grief throug beautifully modulated gestures, and an expressiveness that range from the quiet weeping of St John, the scream of the beautiful ardent Mary, to the grimace of pain of Mary Magdalen. The sma angelic spirits are borne by cloudlets that seem to have suddend materialized on the blue background, their profound expressivenes has been united with a solidity of form and an articulation of feature rendered with great freedom yet admirable control.

When the right transept was completed, Giotto's team of painters went on to fresco the vault above the high altar. In the most striking of these frescoes, *St Francis in Glory*, gold leaf has been use lavishly in the embroidery on the saint's clothing and in the background. Though common in panel paintings, the use of gold in fresco was unusual, considering the cost of the material and the scal of the undertaking. The fact that the fresco decorations in the Lowe Church reach their peak of magnificence in the vault frescoes bear witness to the prevailing tendency of the Franciscan movement at the time: a rejection of the basic tenet of poverty preached by the founder of the order. The development of this trend, particularly from the time of the generalship of Giovanni da Murro, is reflected in the increasing magnificence of the fresco decorations of the Basilic of San Francesco, which becomes evident if we compare the Uppe and Lower Church.

The vault contains four complicated Franciscan allegories: S Francis in Glory, the Allegory of Obedience, the Allegory of Chastit and the Allegory of Poverty. Filled with smiling, joyful figures, the are painted in the same style as the scenes of the infancy of Christ is the right transept. The hand of the assistant traditionally known a the Master of the Vele, whose style is characterized by the astonished expressions of his figures, predominates in these frescoes.

It is difficult to say what degree of affinity there is between the new style of Giotto's workshop and the decoration of the Peruzz Chapel in Santa Croce, which was probably carried out not long after the works described above. There is reason to believe that the Kres Collection Polyptych (Raleigh, North Carolina), which includes the Blessing Christ, the Virgin, St Francis, and the two saint Johns, to whom the chapel was dedicated, is the lost altarpiece of the Peruzz Chapel. Whether or not this is true, it must be admitted that the figure of Christ has close links with the *Blessing Christ* in the rounder above one of the entrances to the right transept of the Lower Church However, the workmanship of this 'slavishly Giottesque' polyptych as it has been described, leaves one reluctant to accept that Giotte was directly involved in its execution.

Unfortunately, the Peruzzi cycle was extensively repainted, and what remains of the original frescoes, revealed during a recent resto ration is in a bad state of preservation. There is still much controvers over the dating of this chapel and that of the Bardi family adjoining it, but the present writer favours a date of between 1310-1316.

ranciscan Allegories. Assisi, Lower hurch.
25. St Francis in Glory.
26. Allegory of Chastity.
27. Allegory of Poverty.

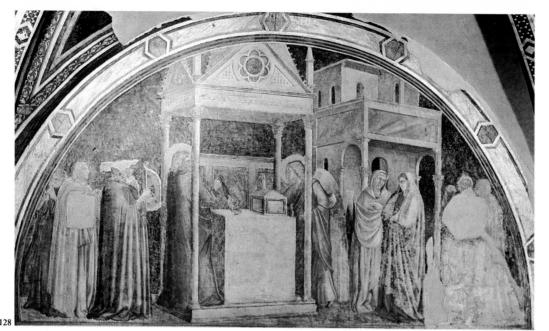

Scenes from the life of St John the Baptist. Florence, Peruzzi Chapel, Santa Croce. 128. Annunciation to Zacharias. 129. Naming of the Baptist. 130. Feast of Herod.

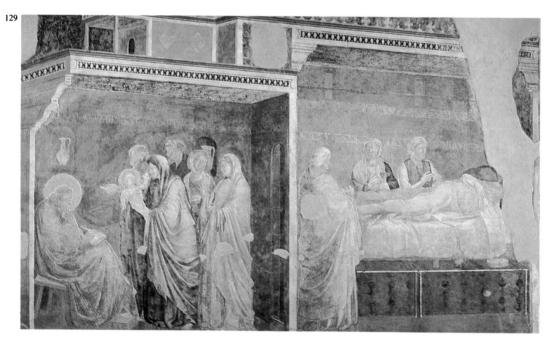

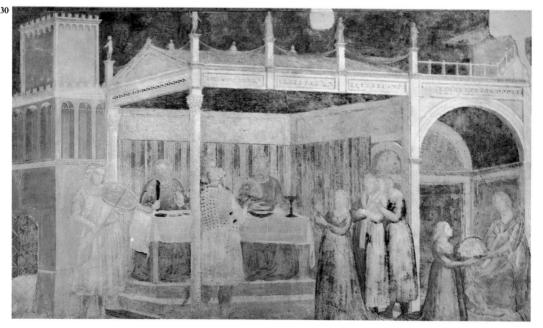

Scenes from the life of St John the Evangelist: Florence, Peruzzi Chapel, Santa Croce. 131. Raising of Drusiana (detail, St John).

he Peruzzi Chapel

The cycle consists of scenes from the lives of St John the Baptist eft wall) and St John the Evangelist (right wall): the Annunciation Zacharias, the Birth and Naming of the Baptist, the Feast of Herod neluding the episode of Salome giving the head of John the Baptist her mother), St John on Patmos, the Raising of Drusiana, and the scension of the Evangelist. The small heads framed by hexagons are most interesting of the minor paintings. They are so lifelike and dividualized that they are thought to be portraits of members of the

The frescoes were planned on an exceptionally large scale. In its respect the cycle would appear to be a continuation of experients begun in the Magdalen Chapel (the Evangelist in the Raising f Drusiana is strongly reminiscent of Christ in the Resurrection of azarus at Assisi). The extensive wall surfaces of the chapel permitted far greater pictorial complexity than did those of the Arena Chapel, and consequently the large, majestic figures that populate the escoes and the architectural structures in which they move so onvincingly is grander than anything at Assisi. As the chapel is very igh, fairly long and narrow, Giotto employed an oblique rather than ontal point of view, imagining the spectator would stand at the napel entrance. Consequently, the buildings are set at an angle, so that the side nearest the entrance is visible.

The relationship of figure and architecture has become much nore harmonious than at Padua, and each architectural structure has nore than enough room for the figures it contains. In the Raising of Prusiana, the architectural background formed of the walls of an istern city is perfectly coherent (no longer the series of separate oxes seen in the Assisi frescoes), and is approximately on the same ale as the figures. The orderly, well-constructed picture space vident in the Feast of Herod and the Ascension of St John the

Evangelist was to be adopted by Maso di Banco, one of Giotto's greatest followers, whose work can be seen in the Bardi di Vernio Chapel in Santa Croce.

However, our judgement of the Peruzzi Chapel frescoes has to remain suspended. It is difficult to envisage their original splendour, and to gauge how much they reflected Giotto's new style. We can only admire the single well-preserved fragment in the chapel, the hand of St John the Evangelist in the scene where he resuscitates Drusiana. It is a work of such strength that we think of Masaccio, and regret deeply the almost total loss of these frescoes.

According to Ghiberti, Giotto decorated four chapels in Santa Croce, and made altarpieces for each chapel. A group of paintings probably made between the decoration of the Peruzzi and Bardi chapels may have constituted one of these altarpieces. It consists of seven square panels (average size 45 x 44 cm) representing the Adoration of the Magi (Metropolitan Museum, New York), the Presentation in the Temple (Gardner Museum, Boston), the Last Supper and the Crucifixion (both in the Alte Pinakothek, Munich), the Entombment (Berenson Collection, Settignano), the Descent into Limbo (Munich), and the Pentecost (National Gallery, London). The presence of St Francis among the group of figures kneeling at the foot of the cross in the Crucifixion, which must have been the central panel, suggests that the work was made for a Franciscan church or chapel.

Although the poor state of preservation of the panels makes their assessment somewhat difficult, Giotto's participation in their execution cannot be doubted. His hand is especially evident in the *Last Supper*, which bears a direct relation, even in the faces of the apostles, to the same scene in the Arena Chapel, while the gallery

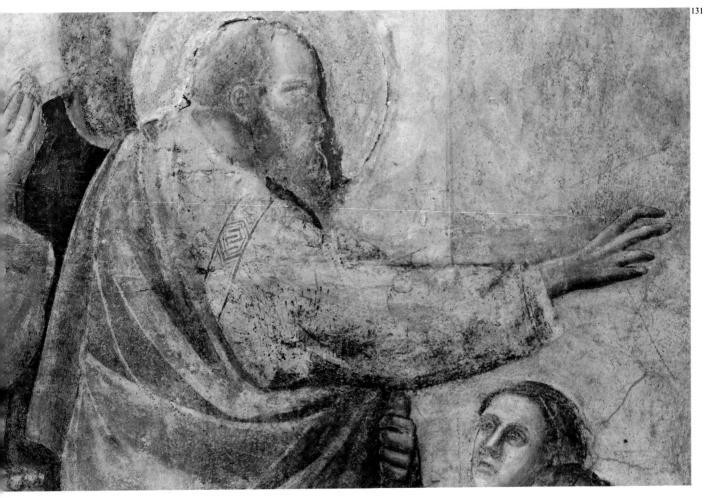

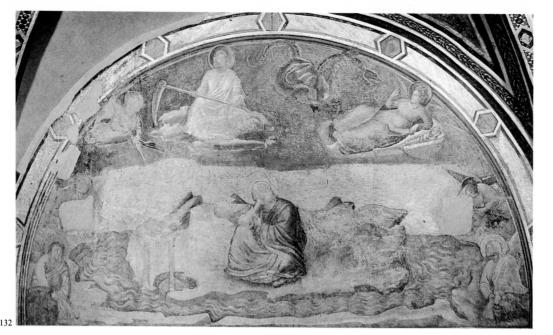

Scenes from the life of St John the Evangelist. Florence. Peruzzi Chapel, Santa Croce. 132. St John on Patmos. 133. Raising of Drusiana. 134. Ascension of the Evangelist.

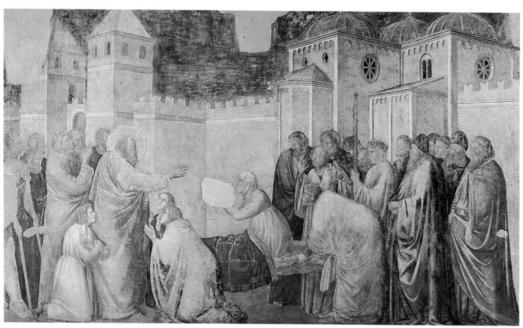

Panel paintings with scenes from the life of Christ. 135. Adoration of the Magi New York, Metropolitan Museum. 136. Presentation in the Temple. Boston, Isabella Stewart Gardner Museum. 137. Last Supper. Munich, Alte Pinakothek. 138. Crucifixion. Munich, Alte Pinakothek. 139. Entombment. Settignar Berenson Collection. 140. Descent into Limbo. Munich, Alte Pinakothek.

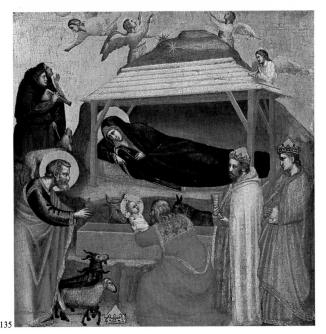

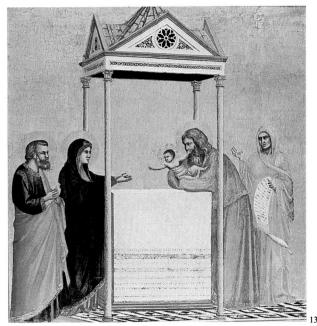

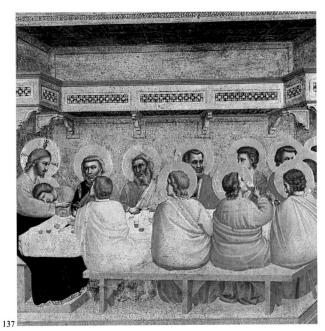

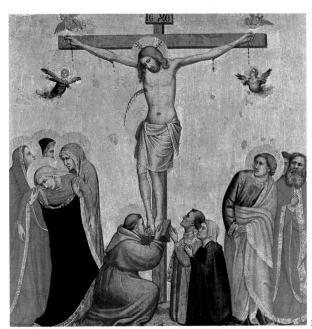

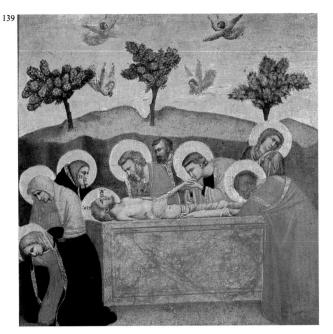

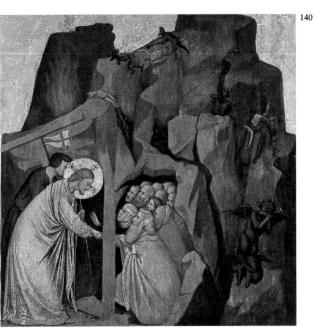

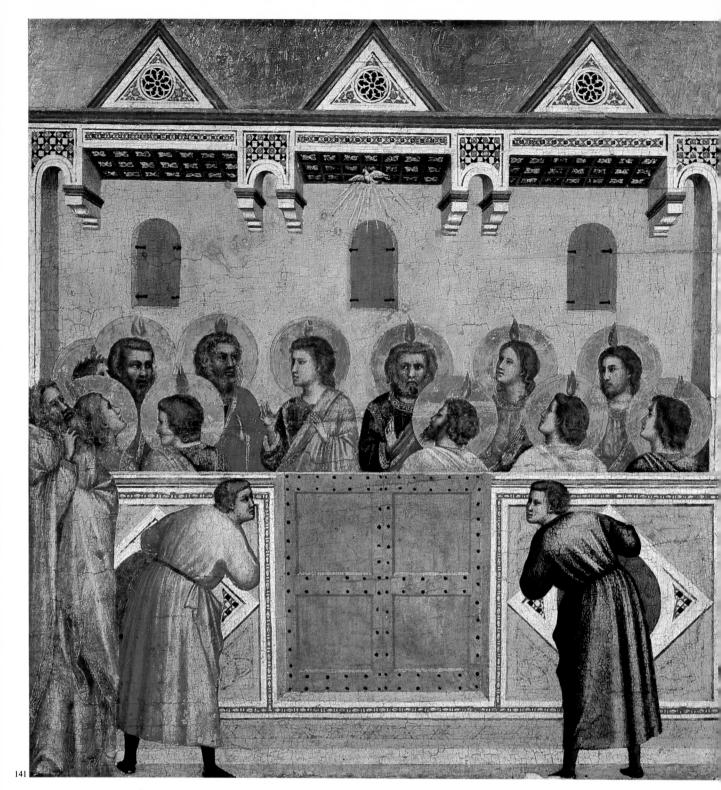

141. Pentecost. London, National Gallery.

Stefaneschi Altarpiece (recto). Rome, Vatican Pinacoteca. 142. Crucifixion of St Peter, Christ Enthroned, Beheading of St Paul. inning along the wall repeats the idea used in the *Marriage at Cana*. he construction of the work is so studied that one suspects that the nall hole visible in the centre of the panel was made by a nail placed tere to secure a string used to draw the perspective lines, a practice at was to become common among fresco painters of the fifteenth entury.

The crucifix in the central panel appears to be closely related to the large painted *Crucifix* in San Felice, Florence, a work whose high utility would be more apparent were the surface freed of its thick yer of dirt. The early date of the San Felice work is revealed not nly by its simple rectilinear shape, but also by the weight of Christ's ody, which recalls the early *Crucifix* in Santa Maria Novella.

The poorly-preserved *Crucifix* in the Louvre and the *Crucifix* in the Church of Ognissanti in Florence must have been painted much ter. The elegance and pathos of the latter reveal its affinities with the frescoes in the right transept and vault of the Lower Church at assist.

The most important of Giotto's later panel paintings is the *'efaneschi Altarpiece*, made for the high altar of St Peter's in Rome, nd mentioned as a work of his in the necrology of Cardinal Jacopo tefaneschi, who commissioned the work. It is a double sided iptych, and has been almost completely preserved (only two of the tree panels of the back predella are missing); it is in the Vatican inacoteca and was recently cleaned.

The scenes on the altarpiece are dominated by the solemn, cramental tone of the central panel on each side, a tone which, recisely because it is unusual in Giotto's work, demonstrates his apacity for adapting his art to the requirements of each new ommission. On the front of the central panel Christ sits on his nrone, raising his right hand in a gesture of benediction, and holding he Book of Revelations in his left. As in thirteenth century paintings

of the Maestà, the throne is surrounded by a group of angels, but here their slightly circular disposition has been subtly adapted. Cardinal Stefaneschi is shown kneeling in the foreground. The crucifixion of St Peter is depicted on the left panel, and the beheading of St Paul on the right. The predella shows the enthroned Madonna, flanked by two angels and the twelve standing apostles. The predella figures have a detached, arcane air, one that calls to mind the rows of saints in Byzantine mosaics.

The central panel on the back of the altarpiece shows St Peter enthroned in the same pose as Christ (he is in fact the Vicar of Christ), flanked by two angels and saints George and Sylvester. The figures kneeling in the foreground are Celestine V, canonised in 1313, and Cardinal Stefaneschi, who is offering a model of the altarpiece. Attention has often been drawn to the singularity of this last detail, which has been conceived with such naturalistic acumen that it calls to mind Flemish painting. On each of the side panels are the solemn figures of two standing apostles.

As a whole, the Stefaneschi Altarpiece is of high standard, and certain parts are remarkable both in conception and execution. This is true, for instance, of the episode on the far left of the scene of the beheading of St Paul, where the very tall Plautilla, standing on a rock, stretches out her hands to receive the cloth — dropped by the saint when he was taken to Heaven by the angels — that floats earthward. The perfect harmony of space and volume (especially in the scene of St Peter enthroned and in the predella scene of the Madonna), the chromatic richness, the subtle Gothic refinement of some figures, and the enchanting, enigmatic expressions of others closely link this complex work to the Lower Church frescoes. We also notice here the draped female figure shown in profile of the left of the decapitation scene has been represented in the same attitude as Mary standing behind St John in the Crucifixion at Assisi.

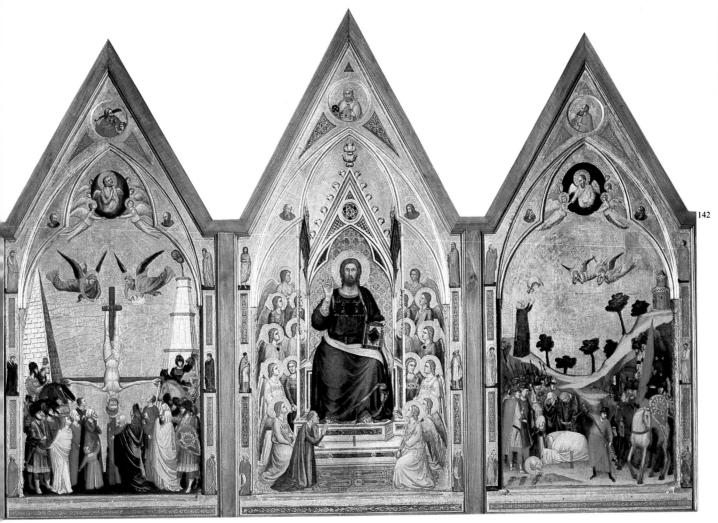

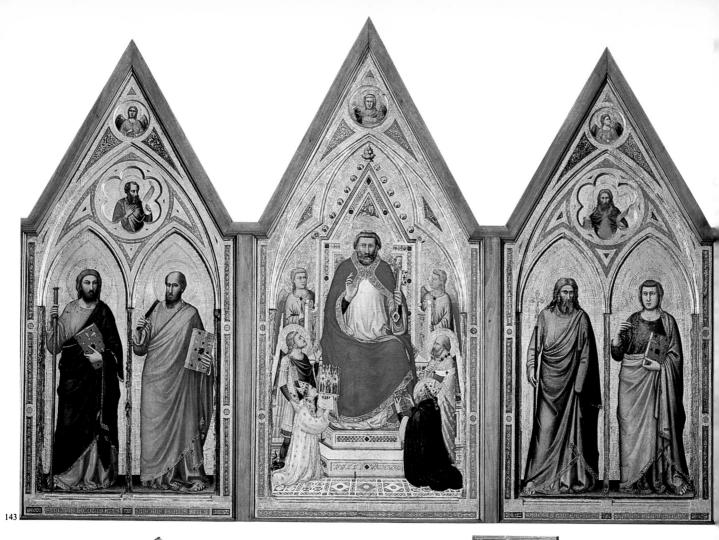

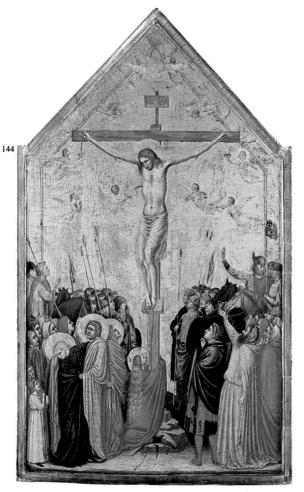

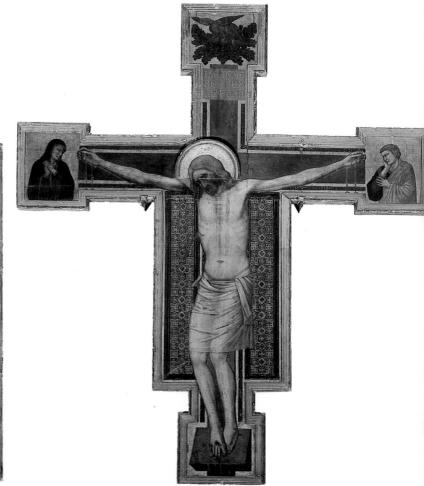

he Bardi Chapel

There are two fine if badly-preserved panel paintings both of the rucifixion which appear to have a close affinity with the Stefaneschi Itarpiece for their delicate proportions, rich colours, and pathos. ne is a gabled panel in the Staatliche Museen of Berlin, the other a ectangular panel in the Musées Municipaux de Strasbourg. The tter forms a diptych with the Wildenstein Madonna Enthroned with vints and Virtues, a work which can be attributed with some cerinty to the Master of the Vele. The novelty of these Crucifixions onsists in the treatment of the crowd at the foot of the cross: one gets te impression that the picture frame has abruptly cut off a small ortion of an immense crowd. A subtle innovation in the Strasbourg anel is the reduction in scale of the horsemen, who thus appear to be n a different plane, and at a greater distance from the foreground gures. The broad sweep of St John's mantle as he raises his hands to is face is of a rhythm so pure that it calls to mind Greek stelae. In oth paintings Christ's body has become elongated. This Christ is far emoved from the realism of the Christ of the Santa Maria Novella rucifix.

This new Gothic tendency characterizes much of Giotto's late ork, which is best represented by the frescoes in the Bardi Chapel of anta Croce. By then the great Sienese painter Simone Martini had eveloped a refined, sophisticated version of Giotto's art, one deeply afluenced by the French Gothic style. He was fast becoming iiotto's most serious Italian rival (he, too, was receiving many ommissions from abroad), and Giotto's response to Martini's access was to modify his own painting, making it more refined and

rnate.

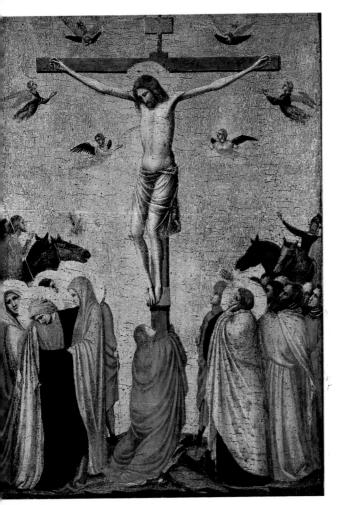

The partially reconstructed polyptych consisting of the Madonna and Child (National Gallery, Washington), St Stephen (Museo Horne, Florence) and Saints John the Evangelist and Lawrence (Musée Jacquemart-André, Châalis) is so close stylistically to the Bardi Chapel frescoes that some of the faces seem to be almost interchangeable. Although they have the solemn bearing found in all of Giotto's large scale paintings, the figures in these panels are distinguished by their aura of luxury and wealth. The Madonna, who has the long narrow eyes of her counterpart on a French ivory, seems to have arrayed herself magnificently in a mantle the folds of which anticipate the impression of warm, velvety luxury created by certain of Gentile da Fabriano's paintings. St Stephen is dressed in a sumptuously ornate dalmatic, and carries a richly bound book. Even though the tone is not as exquisitely worldly and courtly as that of a Simone Martini painting, one feels that Giotto intended these panels to challenge his young Sienese rival.

The Bardi Chapel frescoes did not provide the possibility for such richness, given the rule of poverty imposed by St Francis. However, the elongated figures, delicate colours and pictorial softness are in keeping with the tendency described above. The characters in the scenes from the life of St Francis, again shown in contemporary dress given their close proximity in time, have been given a more earthy, realistic appearance than those in the Peruzzi chapel. The St Francis cycle at Assisi still served as the model for scenes from life, though the limited space in the chapel made it necessary to

restrict the number of episodes represented.

The Renunciation of Worldly Goods appears in the lunette of the left wall; the Confirmation of the Rule in the opposite lunette; St Francis before the Sultan immediately below; the Apparition at Arles on the opposite wall; the Death and Ascension of St Francis below; the Vision of the Ascension of St Francis on the outer wall above the entrance arch. Only three of the original four Franciscan saints represented at the side of the window have survived: Louis of Toulouse, Clare and the badly damaged Elizabeth of Hungary. The painted roundels on the vault enclose badly-preserved allegorical figures: Chastity, Poverty and Obedience; the fourth roundel has not survived.

The Bardi Chapel was completely whitewashed in the eighteenth century, as was the Peruzzi Chapel, and tombs were built against its walls, destroying parts of the frescoes. The frescoes were uncovered in 1852, the missing parts filled in, and the whole surface repainted. When the repaint was removed by the Florentine Soprintendenza alle Gallerie in 1958-59, the original frescoes reappeared in fair condition, save for the unsightly gaps.

Stefaneschi Altarpiece (verso). Rome, Vatican Pinacoteca. 143. St James and St Paul, St Peter Enthroned, St Andrew and St John the Evangelist.

Berlin, Staatliche Museen, Gemäldegalerie. 144. Crucifixion.

Florence, San Felice. 145. Crucifix.

Strasbourg, Musées Municipaux. 146. Crucifixion

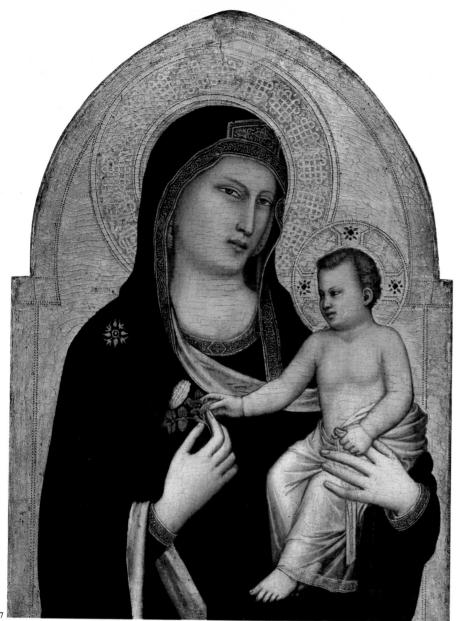

Washington, National Gallery of Art. 147. Madonna and Child.

Florence, Museo Horne. 148. St Stephen.

Châalis, Musée Jacquemart-André. 149. St John the Evangelis 150. St Lawrence.

Scenes from the life of St Francis. Florence, Bardi Chapel, Santa Croce. 151. Apparition at Arles (detail).

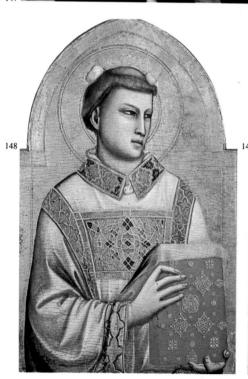

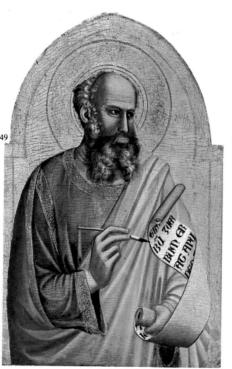

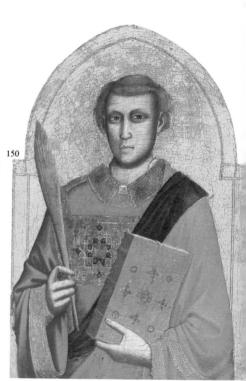

We know both from contemporary sources and from thireenth-century paintings that St Francis was bearded, yet he appears eardless in the Bardi Chapel frescoes. This iconographical irregurity is doubtless linked to the revisionist current in the Franciscan novement, represented by the Conventuals, and to subsequent tempts to modify the image of the most popular saint in hristendom, a change that involved not only denying his traditional ssociation with poverty, but also his physical appearance. At a time when the beard was regarded with distaste by the members of polite poiety, a subtle intention lay hidden in the omission of St Francis' eard, an iconographical deviation that orginated in the Papacy owards the end of the thirteenth century.

The Bardi Chapel frescoes condense the saint's life into a series f representative events: his renunciation of worldly goods, papal ecognition of the Franciscan Order, his vocation as missionary to the last (at the time of the Crusades), a miracle performed during his fetime, his stigmatization, and two miracles performed after his leath. The plan differed from that of the Peruzzi frescoes in that the pectator was envisaged as standing approximately in the centre of he chapel, facing either of the side walls. The arrangement of the cenes on different levels was taken into account, and the buildings in he uppermost scenes accordingly foreshortened. This is evident in he magnificent structure in the background of the Renunciation of Worldly Goods, which was to provide a rich source for Taddeo Gaddi, Giotto's faithful follower, whose studies of oblique buildings vere to culminate in the magnificent structure in the *Presentation in* he Temple in the Baroncelli Chapel of the same church. Just as the eruzzi frescoes were important to the formation of Maso di Banco, hose in the Bardi Chapel greatly influenced the development of Gaddi, who drew inspiration from them for a series of scenes from he life of St Francis he painted on the panel of a Sacristy cupboard loor in Santa Croce (now in the Galleria dell'Accademia, Florence). He was also to remain faithful — to the very end of his long career o the robust but long-limbed figures of the Bardi Chapel frescoes. The Confirmation of the Rule was the direct source of Giovanni da Milano's Expulsion of Joachim from the Temple, a solemn symmerical construction of buildings and figures painted in the Rinuccini Chapel of Santa Croce in about 1365.

The St Francis cycle in the Bardi Chapel lacks the liveliness of its Assisi counterpart, and gives the impression of being separated from us in time by a curtain of sanctity. Yet certain features, like the angry tather in the *Renunciation of Worldly Goods* and the figure of St

Anthony in the Apparition at Arles, were clearly inspired by the Assisi cycle. The scenes here are much more unified and symmetrical, the paint is full and velvety, the colours light and delicate. Clarity and order are still the fundamental principles. We notice the careful arrangement of the friars behind St Francis in the Confirmation of the Rule, and the balanced composition of the Apparition at Arles, which is prevented from being monotonous by devices such as the row of heads placed behind the low dividing wall to suggest greater depth; the inclusion of the marvellous figure of the young friar absorbed in thought, and the gradual darkening of the shadow cast by the roof on the white wall, which produces an effect so subtle that it anticipates Fra Angelico's fresco of the Annunciation, made more than a century later, in one of the cells of San Marco.

We cannot help but admire the balance maintained between the studied precision of the composition and the eloquent expression of grief in the *Death and Ascension of St Francis*, where a small group of friars is gathered round the pale figure of the dead saint, expressing their profound sorrow with great dignity. A comparison of this scene with the Paduan *Lamentation* clarifies the distinction that Giotto intended to maintain — to speak in Dantesque terms — between the 'tragic' level of the life of Christ as told in the Bible, and the 'comic' level of the legend of an almost contemporary saint.

The presence of Louis of Toulouse among the saints represented at the sides of the window provides one indication of the date of the Bardi frescoes, as they cannot have been painted before 1317, the year he was canonized. The stylistic similarity of these frescoes to Giotto's last works, and even to the frescoes in the Bargello Chapel in Florence, which were completed by his workshop a few months after his death, place them in a late stage of the artist's career.

In the last years of his life Giotto's energies were divided between his role as master builder of Florence Cathedral (this was when he began work on the Campanile, the so-called 'Giotto's Tower') and prestigious commissions throughout Italy (between 1329 and 1333 he was working in Naples for Robert of Anjou; in about 1335, according to Villani, he was in Milan, working for Azzone Visconti). But he still found time to oversee the activity of his efficient workshop, which was producing ambitious, richly coloured works such as the polyptych in Bologna (made for the Church of Santa Maria degli Angeli, and now in the Pinacoteca), and the altarpiece in the Baroncelli Chapel in Santa Croce, both of which bear his signature.

Flanked by four stern saints, the Madonna of the Bologna polyptych sits on a throne that is the most Gothic of all the thrones

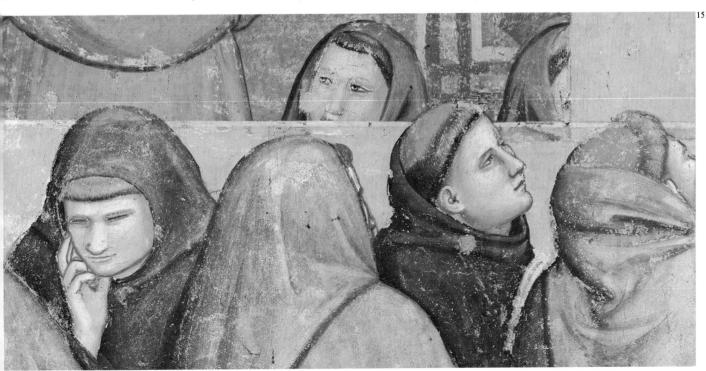

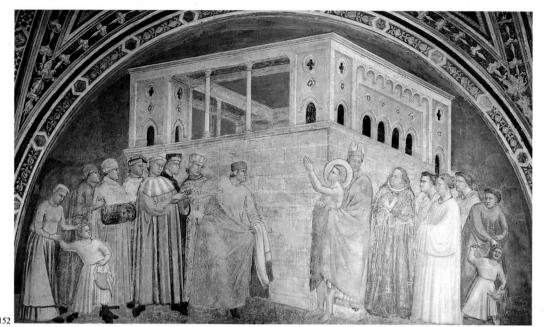

Scenes from the life of St. Francis. Florence, Bardi Chapel, Santa Croce.
152. Renunciation of Worldly Goods.
153. Apparition at Arles.
154. Death and Ascension of St Francis.

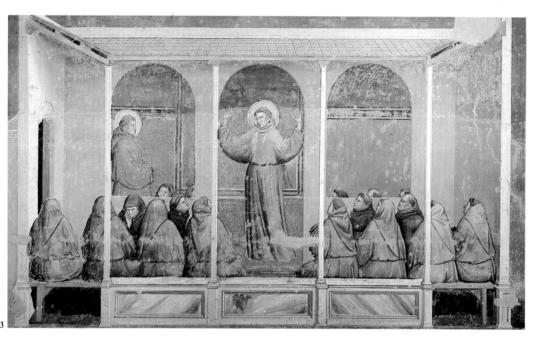

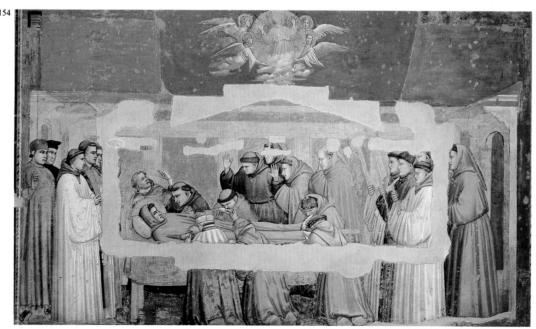

cenes from the life of St rancis. Florence, Bardi hapel, Santa Croce.
55. Confirmation of the ule.
56. St Francis before the ultan (Trial by Fire).
57. Vision of the Ascension f St Francis.

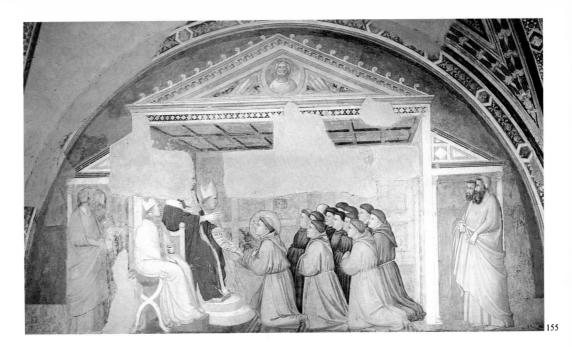

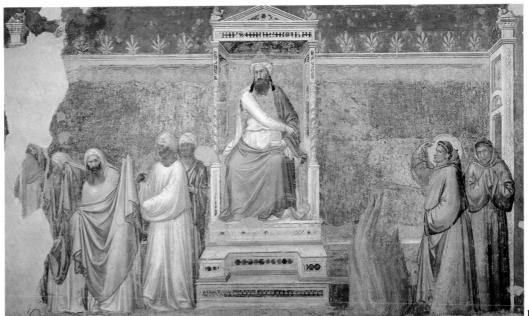

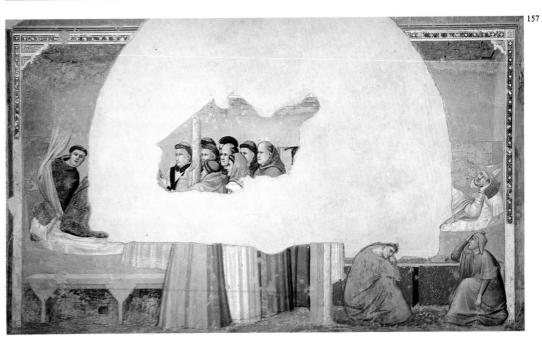

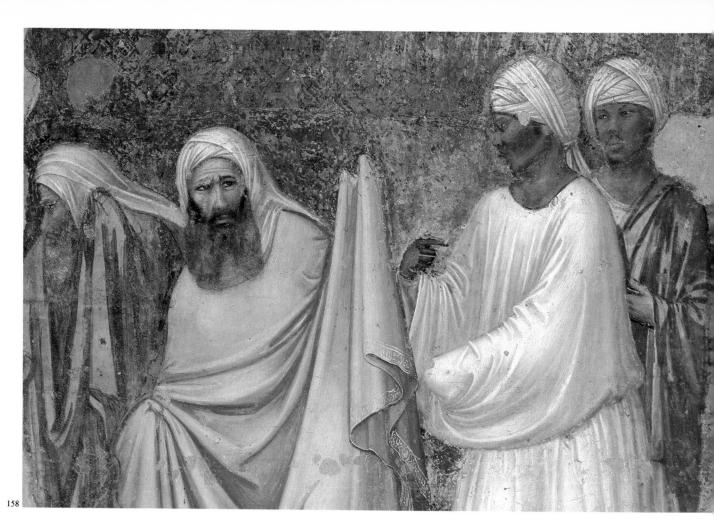

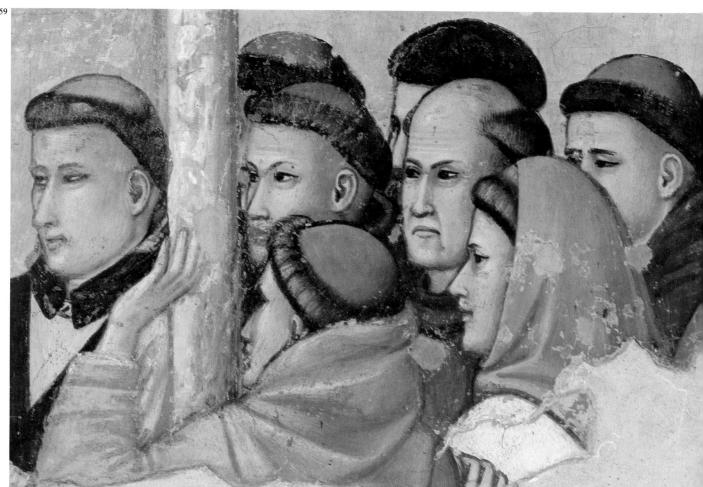

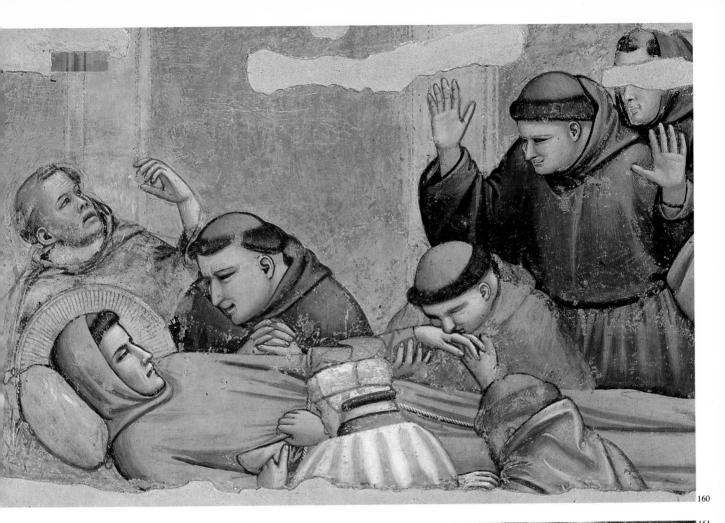

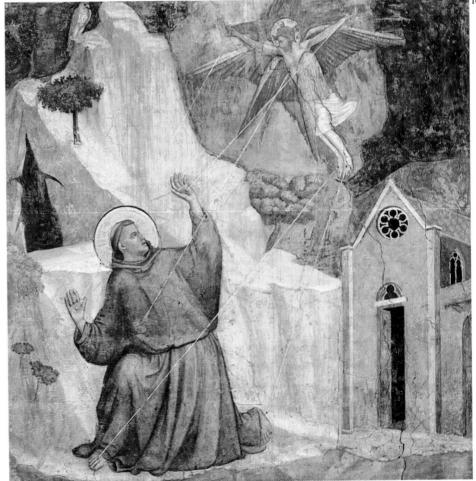

Scenes from the life of St Francis. Florence, Bardi Chapel, Santa Croce.

158. St Francis before the Sultan (detail).

159. Vision of the Ascension of St Francis (detail).

160. Death and Ascension of St Francis (detail).

161. Stigmatization of St Francis.

Bologna, Pinacoteca. 162. Bologna Polyptych (St Peter, Archangel Gabriel, Madonna and Child, Archangel Michael, St Paul).

Florence, Santa Croce. 163. Coronation of the Virgin (Baroncelli Polyptych).

Florence, Bargello Chapel. 164. Last Judgement (detail, the Blessed, including portrait of Dante).

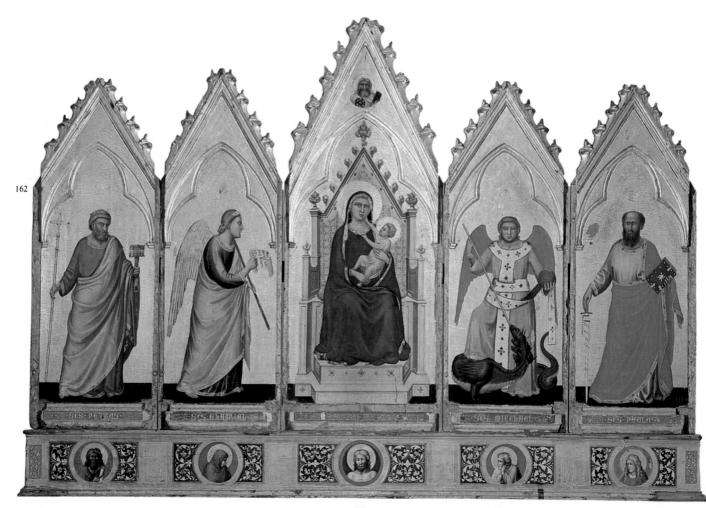

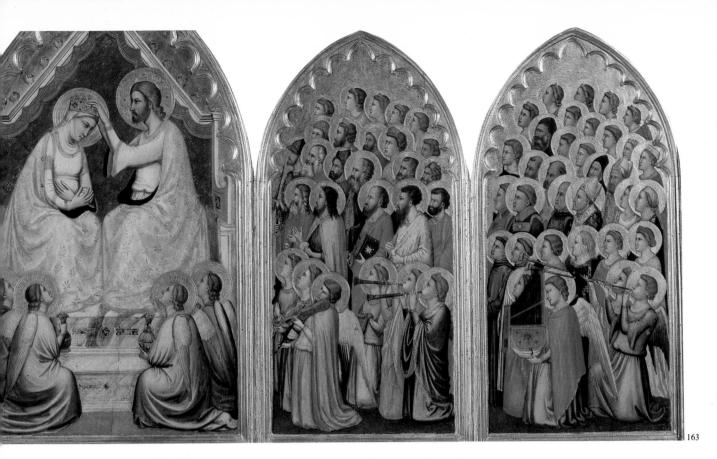

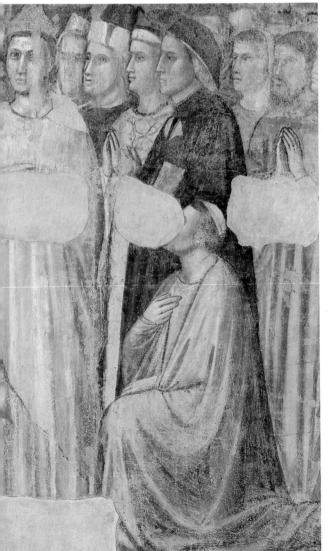

painted by Giotto. She has the demeanour of an elegant, almost worldly lady. The lovely decorations and the brilliant, shimmering colours contribute to the richness of this work. The resplendent *Coronation of the Virgin* in the Baroncelli Chapel, which was decorated not before the end of the 'twenties, is undoubtedly one of Giotto's last great conceptions. The neat, colourful rows of beatific souls on the side panels suggest that paradise is a place of perfect order; and perspective! One feels that the side panels could continue into infinity, making it a boundless paradise. In contrast, the central panel with the elegant figures of Christ and the Virgin has something of the refined worldliness of a court ceremony.

Giotto's influence on the frescoes in the Bargello chapel is most evident in the scene of the *Last Judgement* on the back wall (although badly deteriorated, we can still make out a few beautifully painted heads of the blessed). He died in early 1337, before the frescoes had been completed. He had followed a path which led from the revolutionary vitality of the frescoes in the Upper Church at Assisi, through the more serene classical narrative of the Arena Chapel frescoes, to the warm chromatic frescoes of his second sojourn at Assisi, the starting-point for his last, refined Gothic period.

In his lifetime Giotto had raised painting to a prestigious level among the arts, to such a high level that it influenced sculpture rather than vice versa, as is demonstrated by the work of the great Andrea Pisano. Italian painting can be said to have changed more radically with the appearance of Giotto than ever before. The impulse that Giotto gave to the arts was so great that it determined the destiny of European painting. By the middle of the fourteenth century Europe had already become aware of Giotto's innovations, which accorded with the growing secular tendency in European society. His rediscovery of the third dimension, of real and measurable space, of the natural appearance of surfaces, of the individualizing aspects of reality — all this became the inheritance of European art.

Contents

Early Works	3
The Legend of St Francis	13
The Arena Chapel	31
The Lower Church at Assisi	59
The Peruzzi Chapel	65
The Bardi Chapel	71

© Copyright 1981 Scala Istituto Fotografico Editoriale, Firenze

Photographs: Scala (Angelo Corsini, Mario Falsini and Mauro Sarri) except illustrations 50 (Réunion des musées nationaux, Paris), 115, 144 (Staatliche Museen, Berlin), 135 (Isabella Stewart Gardner Museum, Boston), 138, 140 (Kunst-Dias Blauel, Gauting bei München), 141 (National Gallery, London), 146 (Musées municipaux, Strasbourg), 147 (National Gallery of Art, Washington), 149, 150 (Arts graphiques de la Cité, Paris).

Printed and bound in Italy by Sogema Marzari Schio 1989